MILWAUKEE ART MUSEUM

FRIENDS OF ART
CELEBRATING
50 YEARS

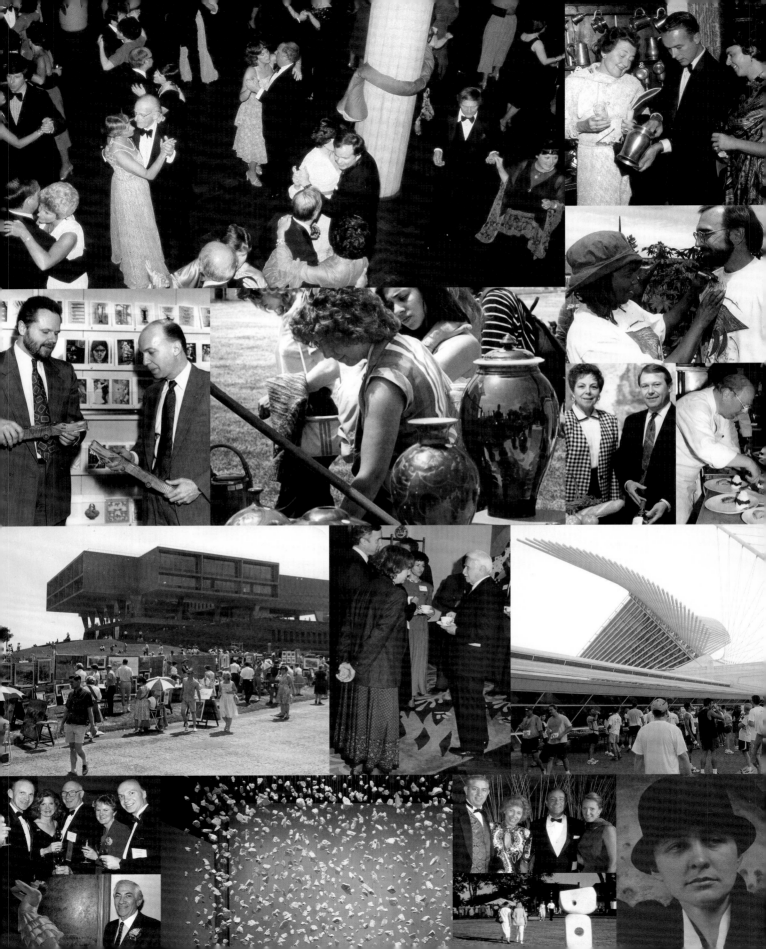

MILWAUKEE ART MUSEUM

FRIENDS OF ART
CELEBRATING
50 YEARS

Russell Bowman

Thomas Connors

MILWAUKEE
ART MUSEUM

MILWAUKEE
ART MUSEUM

F50A
FRIENDS OF ART
FIFTY YEARS OF SUPPORT

Milwaukee Art Museum Friends of Art: Celebrating 50 Years

Russell Bowman, Thomas Connors

Published by Petullo Publishing LLC., 219 North Milwaukee Street, Third Floor, Milwaukee, WI 53202
in cooperation with the Milwaukee Art Museum, 700 North Art Museum Drive, Milwaukee, WI 53203

LIbrary of Congress Control Number: 2007934634

ISBN 978-0-944110-91-1

Designed and produced by Steve Biel
Edited by Karen Jacobson

Printed by The Fox Company, Inc., West Allis, Wisconsin

Front cover: Duane Hanson, *Janitor*, 1973 (page 78); back cover: *Coffeepot*, 1765-90 (page 79)
Page 5: Claes Oldenburg, *Trowel—Scale A 3/3*, 1970 (page 78)

Photography of the Museum collection: John R. Glembin, Larry Sanders, John Nienhuis, Dedra Walls, P. Richard Eells, and Efraim Lev-er.

Additional photography: Lila Aryan, Richard F. Bauer, Dennis Buettner, Jeff Millies, Shimon/Lindemann Photographers, and Dedra Walls.
Photo page 29: *Milwaukee Sentinel*, June 24, 1965, ©2007 Journal Sentinel Inc. reproduced with permission.
Photo page 30: *Milwaukee Journal*, June 26, 1964, ©2007 Journal Sentinel Inc. reproduced with permission.

Specific credit for individual photographers is available upon request.

The Milwaukee Art Museum wishes to thank the following for permission to reproduce works in this volume.
Abbott—©Berenice Abbott/Commerce Graphics, NYC. Adams—©Trustees of The Ansel Adams Publishing Rights Trust. Bearden—Art ©Romare Bearden Foundation/Licensed by VAGA, New York, NY. Brown—©The School of the Art Institute of Chicago and the Brown family. Calder—©2007 Calder Foundation, New York/Artist Rights Society (ARS), New York. Callahan—©The Estate of Harry M. Callahan, Courtesy Pace/MacGill Gallery, New York. Carrà—©2007 Artist Rights Society (ARS), New York/SIAE, Rome. Close—©Chuck Close, Courtesy PaceWildenstein, New York. Evans—©Walker Evans Archive, The Metropolitan Museum of Art. Hanson—Art ©Estate of Duane Hanson/Licensed by VAGA, New York, NY. Hesse—©The Estate of Eva Hesse. Hauser & Wirth Zürich London. Johns—Art ©Jasper Johns/Licensed by VAGA, New York, NY. Kertész—©The Estate of André Kertész/Higher Pictures. Kiefer—©Anselm Kiefer. Meidner—Ludwig Meidner-Archiv, Jüdisches Museum der Stadt Frankfurt am Main. LeWitt—©2007 Estate of Sol LeWitt/Artist Rights Society (ARS), New York. Marden—©2007 Brice Marden/Artist Rights Society (ARS), New York. Martin—©2007 Agnes Martin/Artist Rights Society (ARS), New York. Moore—The work illustrated on page 64 has been reproduced by permission of the Henry Moore Foundation. Morris—©2007 Robert Morris/Artist Rights Society (ARS), New York. Oldenburg—©2007 Claes Oldenburg and Coosje van Bruggen. Parker—Courtesy the artist and Frith Street Gallery, London. Segal—Art ©The George and Helen Segal Foundation/Licensed by VAGA, New York, NY. Sherman—Courtesy of the artist and Metro Pictures. Stieglitz—©2007 Georgia O'Keeffe Museum/Artist Rights Society (ARS), New York. Strand—©Aperture Foundation Inc., Paul Strand Archive. Winogrand—©1984 The Estate of Garry Winogrand, courtesy Fraenkel Gallery, San Francisco.

Contents

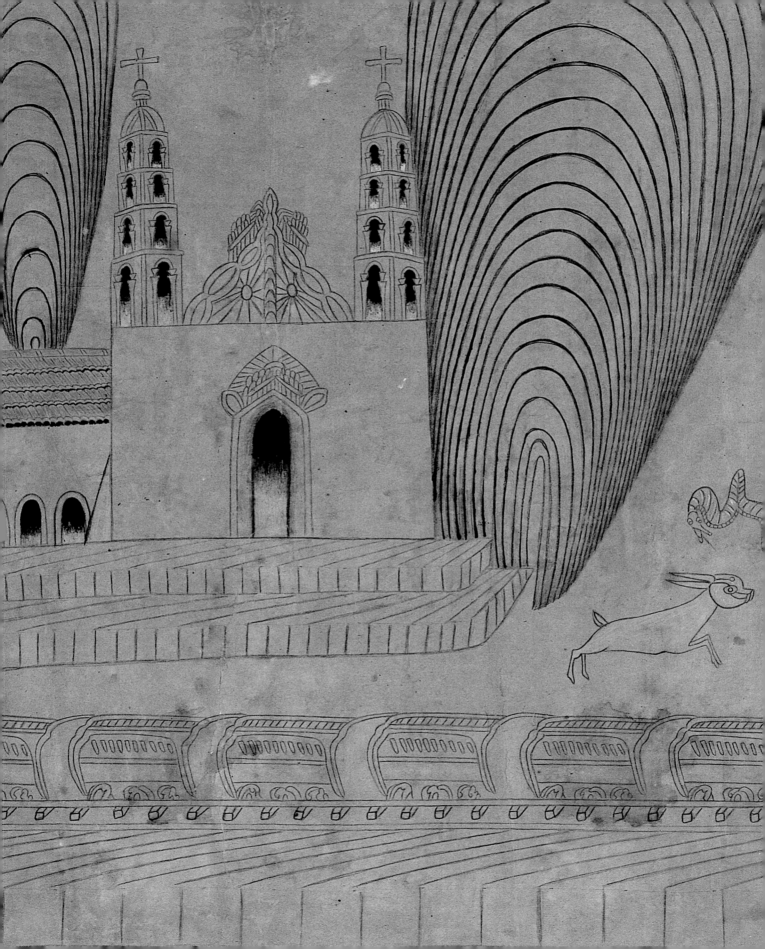

Foreword

DAVID GORDON | DIRECTOR, MILWAUKEE ART MUSEUM

Friends of Art (FOA) has been the source of funds for almost 250 donations of art to the collection of the Milwaukee Art Museum since 1957, and like the Museum, FOA shows no signs of slowing down. Even as the Museum grows in ways that no one could have imagined 50 years ago, Friends of Art continues to support acquisitions that bolster its artistic vision.

Those familiar with the Milwaukee Art Museum are not surprised to discover that many of its signature works, such as Duane Hanson's *Janitor* (1973) and Eva Hesse's *Right After* (1969), in the modern galleries, or Nardo di Cione's breathtaking *Madonna and Child* (ca. 1350), in the galleries of European art, came to the Museum thanks to Friends of Art. Friends of Art has always dared to support the acquisition of works that contribute to developing the impressively diverse and surprisingly unique nature of the Museum's collection. At any given time there are more than 10 works by folk and self-taught artists acquired with Friends of Art support on display in collection galleries. Pieces by the fascinating Milwaukee native Eugene von Bruenchenhein, an artist whose work truly comes to life in our museum, are particularly of note.

More than just a support group, Friends of Art has proven to be an invaluable source of encouragement throughout the years. Consider a piece like Agnes Martin's *Untitled #10*, which is reproduced in this volume. An abstract painting created in 1977, the work was acquired by Friends of Art and donated to the Museum just four years later, in 1981. Bringing to Milwaukee this piece, the work of a living female artist who had never been formally recognized in a museum exhibition, was the kind of bold move that this institution thrives on. The Museum has always sought to acquire works before an artist's reputation—and price—has taken off.

In 1986 my predecessor Russell Bowman, who had a long and fruitful relationship with Friends of Art, described Martin's technique in *Untitled #10* as a means of severely limiting painting to its essentials: "Paint on a flat surface with a composition evolved from the shape of the canvas itself." Anyone who has had a chance to see this work knows how deceptively complex the results of this simple method can be. Friends of Art operates in much the same manner: by serving as an unwavering and loyal source of support for the community, the group has helped to develop an institution that is richly nuanced and endlessly multifaceted.

As the worlds outside and within the Museum keep on growing, all of us in the constituent communities of the Milwaukee Art Museum benefit from Friends of Art, and we will continue to owe this group a sincere debt of gratitude not only for its gifts to the Museum but also for the enjoyable events that raise the money for them and for the many hours of volunteer work that go into their organization. Art Lives Here thanks to Friends of Art. Enjoy this book, and then visit the treasures of art in your galleries!

OPPOSITE: **Martín Ramírez**, *Untitled (Landscape with Train, Church, and Animals)*, ca. 1950s (detail) (see page 75)

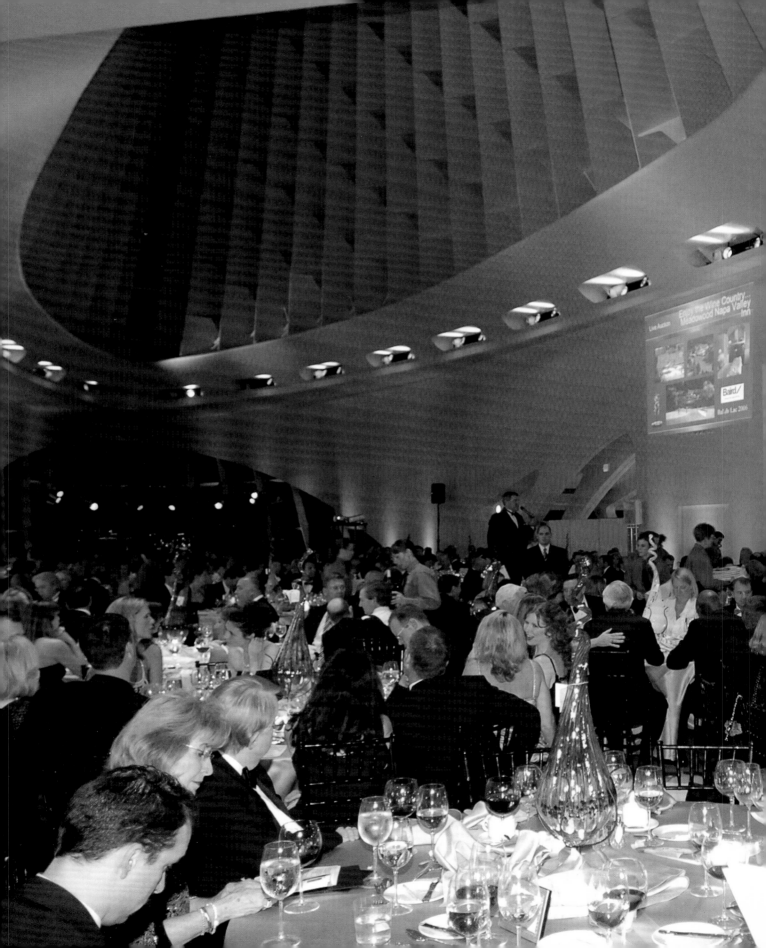

Introduction ED HANRAHAN | PRESIDENT, FRIENDS OF ART

In this historic year, as we mark the 50th anniversary of Friends of Art (FOA), I am honored to represent the organization as its president, but the real story belongs to those who started the organization in 1957 and those who have nurtured and supported it over the past five decades. FOA has been fortunate to have a long run of board members, committee members, staff, and volunteers who have been committed and passionate about supporting the Milwaukee Art Museum through acquisitions and exhibitions.

What the board, staff, and volunteers gave unselfishly to the Museum at every FOA event was their time: time spent licking envelopes, selling soda and beer, and setting up tables, chairs, and tents. They carefully designed and executed event plans. They prepared proposals, budgets, and financial statements. They logged shift after shift in hot, cramped ticket booths. They picked up garbage, made phone calls, addressed envelopes, solicited auction items, wrote letters, and stood in muddy fields waiting for the rain to stop. They gave up their lunch hours, nights, and weekends and spent many Father's Days at the Lakefront Festival of Arts. This time, dedication, and perseverance produced meaningful results, and many of the fruits of their labors are on view today at the Museum. Indeed, some of the Museum's most important works were gifts from the Friends of Art.

With this book, our goal is not only to highlight the remarkable artworks gifted to the Museum but also to tell the story of Friends of Art—and the story really is the events that we have produced and the people who make up our group. FOA has created and organized highly visible events that have attracted millions of people over the years, bringing some to the Museum for the first time and exposing them to its beauty and to the benefits of membership. Our members are a group of people who really enjoy their volunteer work and the people they work with. People from all walks of life work alongside one another at FOA events. Many of our volunteers have given more than 20 years of service to FOA, and many within the Museum's board and leadership got their start as volunteers with FOA.

There are countless people to thank for making this project possible, and we are grateful to all who have worked on it and supported it, but there has been one driving force from its inception to its final execution: Tony Petullo— longtime FOA member, past president, and supporter—made this project possible. I can honestly state that this book would not have happened without his involvement. We sincerely thank Tony for all he has done for this project and for all he has done over the years for FOA.

As we celebrate and remember 50 years of Friends of Art, we also look forward to the contributions and achievements of the next 50 years. We hope that you enjoy this publication and that it inspires you to come to the Museum with family and friends to see these extraordinary works of art for yourself and to continue to support Friends of Art.

OPPOSITE: Bal du Lac 2006 at the Milwaukee Art Museum's Windhover Hall.

Acknowledgments ANTHONY J. PETULLO | PUBLISHER AND PAST PRESIDENT, FRIENDS OF ART

This book was published to honor the thousands of Friends of Art (FOA) volunteers who have presented more than 250 public events over the last 50 years. Their goal was to raise money for art acquisitions for the Milwaukee Art Museum. In recent years the goal has been expanded to include exhibition sponsorship as well. The contents of this catalogue illustrate how enormously successful those dedicated volunteers have been over the past five decades. Their almost 250 donations of art have substantially enhanced the Museum's permanent collection, making FOA one of the largest art contributors in the institution's history.

It is my pleasure to thank the many people who contributed to the making of this book. FOA members, past and present, provided firsthand stories, newspaper articles, and photographs that have brought the project to life. The following members of the 50th-anniversary committee provided invaluable advice and assistance: Dwight Ellis, Ed Hanrahan, Ed Hashek, Linda Lundeen, Bill Manly, Dan Nelson Sr., Jill Pelisek, Tim Ryan, and Larry Schnuck.

The catalogue could not have been produced without our very competent Museum staff. A special thank-you goes to Laurie Winters, curator of earlier European art, for coordinating the selection of artworks and the creation of a master checklist for this volume. Additional advice on the choice of works was given by Lisa Hostetler, assistant curator of photography; Mary Weaver Chapin, assistant curator of prints and drawings, and Sarah Fayen, assistant curator of the Chipstone Foundation and adjunct assistant curator of decorative arts for the Museum. Joe Ketner, chief curator; Barbara Brown Lee, chief educator; and Russell Bowman, former director of the Museum, also provided assistance throughout the selection process. Photographer John R. Glembin handled all our last-minute requests with speed and alacrity. And Dawn Frank, registrar, and Melissa Hartley Omholt, assistant registrar—the official "guardians" of the Museum's collection—handled all the photography and reproduction rights with their usual aplomb.

Research on the 50-year history of FOA would not have been possible without the able assistance of the staff of the Museum Library. Beret Balestrieri Kohn, audio visual librarian, provided access to a massive collection of FOA event slides and archival photographs that vividly tell the history of the organization. And Heather Winter, librarian/archivist, assisted with FOA documents, correspondence, agendas, announcements, and other valuable historical information that ultimately made it possible to tell the story of FOA.

Our gratitude goes to Beth Hoffman, who has been director of FOA events and programs for 26 years; Chad Piechocki, FOA events manager; and administrative assistants Janie Klug and Dionne Wachowiak for their help in keeping everything organized.

We are pleased that our essayist Thomas Connors conducted many interviews with past and present FOA leaders and Museum staff members to write a marvelous short history of FOA's 50-year support of the Museum—not an easy task. We are especially grateful to Jane Doud, the first FOA president in 1957, for her colorful history of FOA and the

Museum, without which our story would have been incomplete. Roger Boerner, FOA president in 1962, also contributed much to the early history. Others interviewed for Tom Connors's essay include: Museum staff members Laurie Winters, Barbara Brown Lee, and Beth Hoffman; past FOA presidents Reva Shovers, Tom Godfrey, Tony Petullo, Judy Hansen, Dale Faught, and Pamela Shovers; and longtime FOA leaders Sally Birmingham and Dan Nelson Sr.

We are delighted that Russell Bowman, who was also among those interviewed for Tom Connors's essay, wrote his own essay about his more than 20-year association with FOA. His invaluable insight provided an overview of the almost 250 artworks donated over the entire 50-year period. And we thank Museum director and chief executive officer David Gordon for his introduction and current FOA president Ed Hanrahan for his comments.

1974 Lakefront Festival of Arts co-chairs
Tony Petullo and Jill (Stocking) Pelisek

We applaud Steve Biel, the Museum's former director of design and publications, for creating a marvelous design and layout for the book and for overseeing the activities of all the principals involved. Karen Jacobson was the ever-efficient and expert editor. And we were delighted to have the book printed by Fox Company Inc., a Milwaukee company.

Finally, I would like to thank the current FOA board of directors for advancing the funds to produce such a magnificent volume. Thanks to the generous donors listed here, however, and to the sales of this publication, the board should recover the advance and have some money left over for another work of art. Those donors are Argosy Foundation, Anthony Petullo Foundation, Richard and Ethel Herzfeld Foundation, Greater Milwaukee Foundation— Terry A. Hueneke Fund, Donald and Donna Baumgartner, Reva and Phil Shovers, Dwight Ellis, Ed Hashek, Carl and Louise Perrin, Dr. James and Dorothy Stadler, Pat Algiers, Polly Beal, Sally and Bob Birmingham, Valerie Clarke, Julia DeCicco, Carole and Dale Faught, Susan Forrer, Ellen Glaisner, W. Scott and Janice Gray, Ed Hanrahan, Beth and John Hoffman, Susan and Raymond Kehm, William M. Manly, Karen McDowell, Kim and Jim Muench, Nancy Munroe and Jon Borkowski, Larry and Kathy Schnuck, Dr. Jeffrey and Pamela Shovers, Susan and Stacy Terris, and Marcia and Kent Velde.

Producing this book was almost as much fun as being a long-ago FOA president.

A History of Unparalleled Support

RUSSELL BOWMAN

Russell Bowman
Milwaukee Art Museum
Director, 1985–2002

OPPOSITE
James Castle, *Untitled (Construction [Doll])*, n.d. (page 78)

In 1980, about three months into my tenure as a new and somewhat untried chief curator at the Milwaukee Art Museum, I presented my first proposed acquisition to the Museum's primary support group, the Friends of Art (FOA). It was a 1977 painting by Minimalist artist Agnes Martin, a work I thought of as practically a classic of contemporary American art. A heated debate arose within the FOA Acquisition Committee about the appropriateness of this very abstract work for a group that raised its funds through the intense efforts of a diverse group of hardworking volunteers. In fact, a member of the committee tearfully asked, "How can we explain to our volunteers buying a work with only a few lines in it?" But the extraordinary commitment of the FOA to the support of the Museum was shown by the fact that the committee eventually voted unanimously to acquire the work, now an indisputable classic of recent American art.

That openness to supporting the Museum's goals has made Friends of Art central to the institution's growth over the past 50 years. As we now look at both the 50th anniversary of the opening of the Milwaukee Art Museum (then the Milwaukee Art Center)—formed through the merger of its predecessor institutions, the Layton Art Gallery and the Milwaukee Art Institute—in the then-new Eero Saarinen–designed War Memorial Center in 1957, and the almost simultaneous organization of the Friends of Art, we can see how deeply integrated they are. The Friends of Art set out with the goals of both building an audience for the newly formed museum and contributing to its collections. Early on, the group established fund-raising activities such as the Bal du Lac and awareness- and audience-building events such as the Lakefront Festival of Arts to develop a community of support for the Museum. And a year after its founding, the group made the first of a series of wide-ranging acquisitions that allowed the Museum to enter new areas of collecting

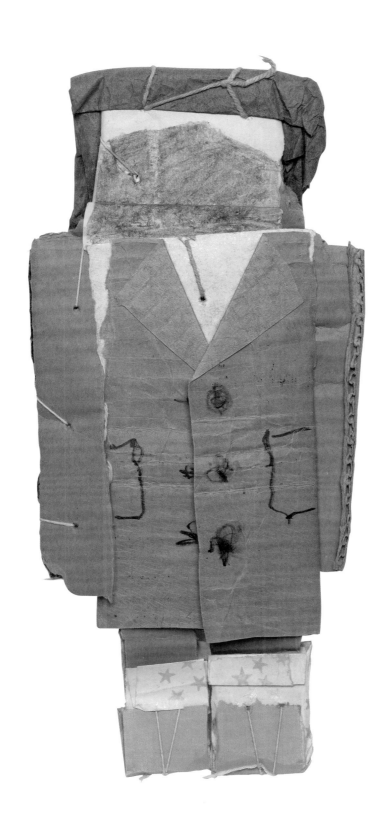

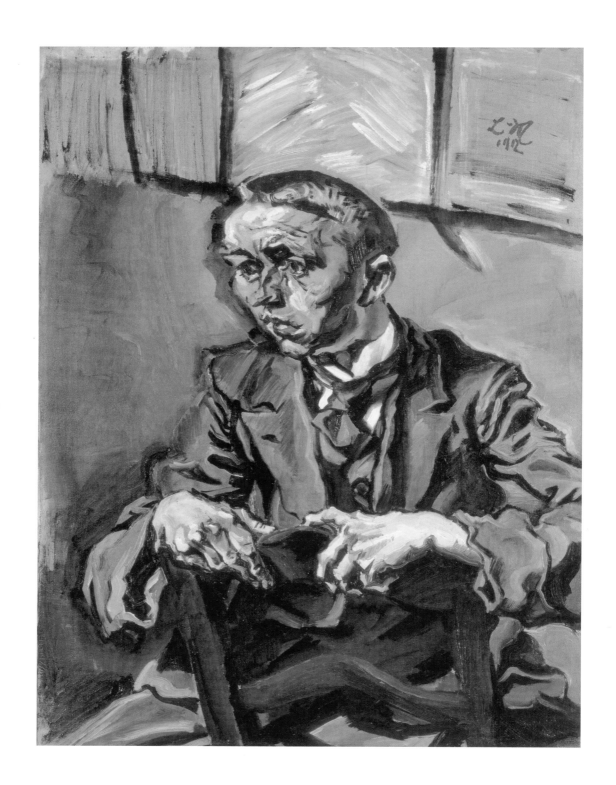

as it sought to define its collection profile in those early years. In ensuing years FOA has contributed consistently to annual operating funds and to capital drives for the 1975 and 2001 additions, but the collection has always been its core commitment and primary achievement.

Contemporary art has been central to both the FOA's acquisition activities and to the institution as a whole. Indicative of this centrality are the early acquisitions—made during the tenure of Edward Dwight, the first director of the Milwaukee Art Museum—of a painting by English artist Ben Nicholson, in 1958, and a sculpture by Henry Moore, in 1959. A distinguishing characteristic of FOA, however, has been to address various areas of the collection, following the Museum's needs, and in 1960 a work attributed to the 18th-century American painter John Singleton Copley was acquired, although its authorship has since been given to another artist. Throughout its existence FOA has had the broadest scope among all the Museum's funders of acquisitions, with gifts that encompass old master and contemporary painting and sculpture, prints and drawings, decorative arts, and eventually photography and folk art.

Tracy Atkinson
Milwaukee Art Museum
Director, 1962–75

OPPOSITE
Ludwig Meidner, *Portrait of a Young Man*, 1912
(page 73)

This wide scope of acquisitions was firmly established during the directorship of Tracy Atkinson (1962–75). Neither the Layton Art Gallery nor the Milwaukee Art Institute collected old master paintings, so the Museum's collection was essentially begun with FOA acquisitions of works by the 15th-century Spanish Siresa Master, in 1963, and the Italian Baroque painter Francesco Solimena, in 1964. A major addition to the existing 19th-century European holdings occurred in 1968 with the purchase of a portrait by French realist Gustave Courbet. The decorative arts collection, which was also supported by the Layton Art Collection, was initiated with acquisitions of 18th-century American furniture and 19th-century Shaker pieces, a connection with the Museum's nascent folk art collection. But the most extraordinary FOA acquisitions of the 1960s and early 1970s were in contemporary art. The list is exemplary and certainly could not be repeated in today's market: paintings by Sam Gilliam, Philip Pearlstein, Ad Reinhardt, Frank Stella, and Tom Wesselmann and sculptures by Alexander Calder, Duane Hanson, Eva Hesse, Claes Oldenburg, and George Segal. The Hanson and the Hesse particularly have come to be signature pieces of the collection: the Hanson, a favorite of local audiences, and the Hesse, a work sought for many national and international exhibitions and publications. Certainly the Museum's contemporary art collection would not have the widely acknowledged strength it has today without these exceptional gifts from the Friends of Art.

Though acquisitions of old master works were more limited during the administration of director Gerald Nordland (1977–84)—with the exception of a beautiful pair of sculptures by Clodion in 1977—the range of FOA acquisitions expanded into significant new areas. FOA continued to

contribute to the American decorative arts collection with important acquisitions of silver by Cornelius Kierstede, in 1977, and Thomas Shields, in 1981. It also actively supported Nordland's program to expand the holdings of American painting and sculpture with works by 19th-century still-life painter Richard La Barre Goodwin, early 20th-century modernist Joseph Stella, and mid-century abstractionist Burgoyne Diller. Contemporary acquisitions continued apace, particularly in sculpture, including works by Robert Arneson, Robert Irwin, Joseph Kosuth, and Reuben Nakian. Certainly the most unusual contemporary acquisition of these years was the large-scale mural commissioned from Wisconsin-born, New York-based Richard Haas for the wall of the Centre Theater Building on Wisconsin Avenue. An homage to lost Milwaukee architectural monuments, it incorporates illusionist reflections of the razed Northwestern Train Station and the Pabst Office Building.

Perhaps the most far-reaching impact of FOA acquisitions in the Nordland years was in the area of photography. Although the Museum had collected a few examples of photography in the 1950s, Nordland, with the support of FOA, began serious collecting in this area in the late 1970s, a period when many other institutions were just becoming active in the field. With matching funds from the National Endowment of the Arts, works were purchased by Americans Berenice Abbott, Ansel Adams, Harry Callahan, Lee Friedlander, Emmet Gowin, Barbara Morgan, Aaron Siskind, Jerry Uelsmann, Garry Winogrand, and others. FOA also made acquisitions in 1980 of photographs by Alfred Stieglitz and Paul Strand and a group of works by Ralph Steiner. In terms of numbers, photography remains the largest area of FOA gifts, and American photographs of the mid-20th century are one of the principal strengths of the Museum's photography collection.

During the years of my directorship (1985–2002) and with the support of the Museum's curators, the focus of FOA acquisitions was on maintaining growth in all the areas that had been established in the previous 25 years and undertaking some new directions as well. One of the commitments was to return to acquisitions in earlier European art, and FOA purchased works by Jan van Amstel and Adriaen van Gaesbeeck. It also contributed significantly to Giovanni Benedetto Castiglione's *Noah and the Animals Entering the Ark*, a gift in 1988 celebrating the centennial of the founding of the Layton Art Gallery; a major proto-Renaissance painting by Nardo de Cione in 1995; and a work by Dutch Caravaggesque painter Matthias Stom in 2000. The acquisition of these works, which anchor the old master collection today, was possible thanks to FOA's openness to joining with other acquisition funds to make major purchases. Simultaneously a commitment to continuing contemporary acquisitions resulted in the addition of works by painters Francesco Clemente, Anselm Kiefer, Susan Rothenberg, and David Salle; photographer Cindy Sherman; and installation artist Cornelia Parker. Reflecting the Museum's developing interest in the craft media, sculptural

Gerald Nordland
Milwaukee Art Museum
Director, 1977–84

Christopher Goldsmith
Milwaukee Art Museum
Executive Director,
1982–2002

OPPOSITE
Jasper Johns, *Untitled*, 1984
(page 73)

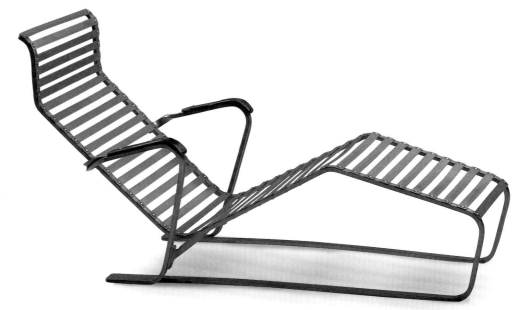

Marcel Breuer, *Reclining Chair*, designed 1932 (page 79)

OPPOSITE
Harry Callahan, *Aix-en-Provence*, ca. 1958 (page 75)

works in fiber by Magdalena Abakanowicz, Walter Nottingham, and Claire Zeisler were added to the collection. Finally, acquisitions by major 20th-century figures were made possible when FOA joined with the Dedalus Foundation to add two paintings by Robert Motherwell in 1994 and with the Museum's Virginia Booth Vogel Acquisition Fund and Contemporary Art Society to make the largest single purchase to date, Jasper Johns's untitled painting of 1984, in 1993. In 2001 FOA entered a partial gift/purchase arrangement with the family of Milwaukee collectors Hope and Abraham Melamed to bring Ludwig Meidner's *Portrait of a Young Man* (1912) into the collection as a centerpiece of the Museum's collection of German art, an area of growing strength.

Beyond painting and sculpture, FOA has actively supported the Museum's holdings of works on paper with gifts of collages by Italian Futurist Carlo Carrà and African American modernist Romare Bearden and drawings by Robert Motherwell, Richard Haas (a presentation drawing for the Centre Theater mural), and contemporary South African artist William Kentridge. Acquisitions in the area of prints ranged from sheets by old masters Canaletto, Giorgio Ghisi, and Giovanni Battista Piranesi and 19th-century figures such as Francisco de Goya, Eugène Delacroix, Honoré Daumier, and Paul Cézanne, many from the collection of artist Philip Pearlstein, to contemporary works by Jackson Pollock, Philip Guston, Lucian Freud, Georg Baselitz, and Brice Marden (represented by *Cold Mountain Series, Zen Studies 1–6*). The photography collection continued to expand with works by 19th-century American Alexander Gardner, significant portraits of Georgia O'Keeffe by Alfred Stieglitz, and contemporary works by Duane Michaels and Wolfgang Tillmans. Acquisitions in the

decorative arts drew away from American furniture, an area ably continued by the Layton Art Collection, to encompass an important 18th-century American sampler; a 19th-century crazy quilt; works by master designers Eugène Gaillard, Marcel Breuer, and Jean Prouvé; and contemporary pieces by Scott Burton and Eero Aarino.

Perhaps the most significant new direction was the broad expansion of the collection of folk and self-taught art that had begun in the 1960s under Tracy Atkinson and had grown substantially with the gift of the Flagg collection of Haitian art in 1991. In 1989 FOA contributed to the acquisition of the nationally known holding of 19th- and 20th-century folk art built by Detroit collectors Michael and Julie Hall. Following the Hall collection, FOA acquired works by 19th-century ship painters John Bard and James Bard; a late 19th-century *bulto*, or religious carving, by José Benito Ortega; a magnificently scaled drawing by institutionalized Mexican immigrant Martín Ramírez; a significant group of paintings, photographs, and ceramics by the self-taught artist Eugene von Bruenchenhein, discovered after his death in West Allis, Wisconsin; and a group of constructions and drawings by mute Idaho artist James Castle. With the Hall and Flagg collections and more recent gifts by Milwaukee collector (and former FOA president) Anthony Petullo, the Milwaukee Art Museum has one of the broadest collections of folk and self-taught art among American museums.

Recent acquisitions under the leadership of director David Gordon and his staff have brought FOA almost full circle: *Wall Drawing #88* by Sol LeWitt, a site-specific work originally shown in a Milwaukee Art Center exhibition in 1971, and a photograph by Walker Evans from 1928 that has become a centerpiece of the American photography collection initiated by FOA in the 1970s.

I learned from that original acquisition presentation to FOA in 1980 that, despite its history of support, I could not take FOA or its many volunteers for granted. We were involved in a learning process—on my part as well as theirs—that was representative of the entire visual arts education role a museum plays in a community. This joint education process was made possible by a mutual respect between volunteers and professional staff that served the institution's needs well. Friends of Art, through 50 years of efforts to build both the Museum's audience and its collections, has been of critical importance to today's Milwaukee Art Museum and its role in presenting exceptional works of art and visual arts programming to Milwaukee, the region, and beyond.

David Gordon
Milwaukee Art Museum
Director, 2003–2008

OPPOSITE
Romare Bearden,
The Street, 1964 (detail),
(pages 52 and 75)

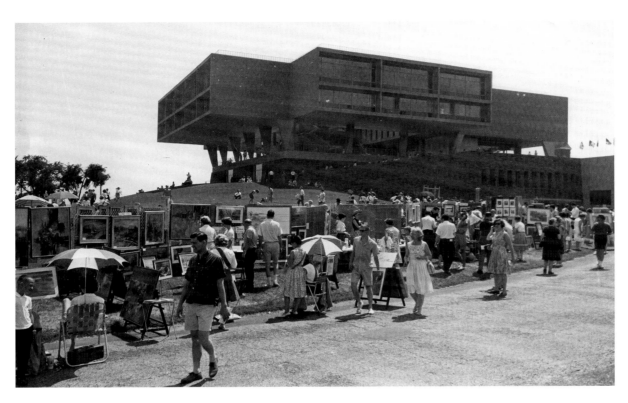

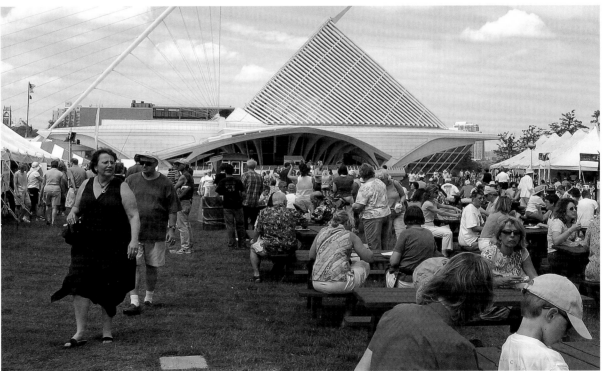

Friends for 50 Years

THOMAS CONNORS

Stroll around the Lakefront Festival of Arts in June, and you feel great. And why not? There's a lot to see and do, and it seems everyone is there: urbanites riding the renewed pulse of the city, art students looking arty, folks who admit they don't quite "get" the Calatrava, suburbanites shepherding their kids—anyone with an interest in art and a good time. And a good time it is. But not that long ago—well, 50 years, but that's nothing in this ever-accelerating age of ours—getting people jazzed about art wasn't easy. The Milwaukee Art Institute, a predecessor of the Milwaukee Art Museum, rarely roped in more than a few dozen people for its openings, and those who showed were board members. And the wildly popular Lakefront Festival of Arts began, humbly enough, with some paintings strung on a clothesline in the country.

Although the Layton Art Gallery had been around since 1888 and the Milwaukee Art Institute was founded in the early 1900s, by the 1950s the city was in a cultural slump. The strains of war and Milwaukee's burden as a Germanic city were enervating. "We did not have a symphony. We didn't have a ballet. People here thought, 'Well, we'll go to Chicago for art and music,'" recalls Jane Doud. "It was weird."

Weird wasn't good enough for Jane Doud. And she was just the person to do something about it. Born in Wisconsin (her mother was a member of the prominent pioneering Wheeler family), Doud studied art at Beloit College before taking degrees at Western Reserve University and the Cleveland Art Institute. For graduate study she traveled to Europe in 1949, where she worked at the Spode and Wedgwood factories in England, at Limoges porcelain factories in France, and at various concerns in Scandinavia. "It sounds unusual," admits Doud, "but rather than go to a school, I decided I wanted to learn how to really do, do the work in glass, do the work in sculpture, do the work in china. It was terribly interesting."

Jane Doud
Co-founder and first president of Friends of Art

OPPOSITE
Top: Festival of Arts, 1963, next to the War Memorial Center

Bottom: Festival of Arts, 2003, in front of the Milwaukee Art Museum's Quadracci Pavilion

In 1950 Doud returned and became director of the extension program of the Milwaukee Art Institute, where attendance was abysmal. "There were three of us working," she says, "and $10 in the treasury." She worked for free, as did the director, Dr. LaVera Pohl. Prior to leaving for Europe, Doud had been teaching art to children and adults in towns throughout Waukesha County. As extension director she built on that experience to increase interest in the institute. On Saturday mornings she and several other artists offered children's classes at the institute's home on Jefferson Street, and Doud soon persuaded the Junior League to sponsor what became the Children's Art Program (CAP).

Although children—with parents in tow—now made their way to the Milwaukee Art Institute for classes, overall visitorship remained dismal. So Doud took matters into her own hands, literally. She loaded paintings from the collection into her station wagon and took them to supermarkets, appliance stores, and libraries in towns around Milwaukee, where she set them up, along with big signs that read, "Come to the Milwaukee Art Institute." Imagine plucking a picture off the wall of the Milwaukee Art Museum and plopping it down in Home Depot. But that was, as they say, a simpler time, and Doud knew that drastic action was called for.

Doud's strategy worked. Folks began to visit the institute. But her efforts didn't end there. Working with fellow art champions Avis Steinman, Alice Klug, and Jane Hall, Doud organized an exhibition of Wisconsin art at Klug's summer home on Beaver Lake, in Waukesha County. "We had a tea and invited 75 people, and we had 1,500 come," says Doud. "We showed 30 or 40 wonderful artists. We had their work on clotheslines."

Subsequent fairs at the home of Mrs. Peter Holbrook and at the Eschweiler Farm—both on North Lake—and later at the Capitol Court shopping center in Milwaukee, drew increasingly larger crowds. As an artist, educator, and concerned citizen, Doud was determined to stimulate an audience for art, and her efforts were beginning to pay off. By the late 1950s, with plans afoot for the Layton Art Gallery and the Milwaukee Art Institute to merge and take up residence in the soon-to-open Milwaukee County War Memorial Center, the need to formalize these volunteer activities became apparent. For a year Doud met with a committee of 50 like-minded individuals, and in June 1957 Friends of Art (FOA) was formed, with Doud as president. It was an ambitious outfit from the get-go. As one member told the *Milwaukee Sentinel* that summer, Friends of Art would be "the great cultural movement that is going to put Milwaukee on the map."

Three months later the Milwaukee Art Institute unveiled its new digs in the War Memorial building with a traveling exhibition of works by Rembrandt, Goya, Cézanne, Van Gogh, and Picasso. Over a five-week run the show drew 56,031 visitors, including—according to *Time* magazine— 7,100 of the throng who'd joined in the fireworks celebration for the pennant-winning Milwaukee

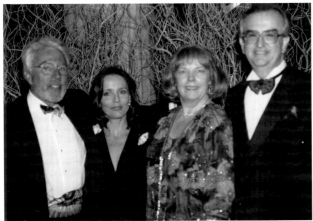

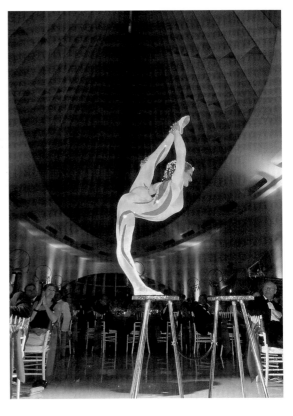

CLOCKWISE FROM TOP LEFT

Bal du Lac 1991 co-chairs Donna and Donald
Baumgartner and Dorothy and James Stadler

Cirque du Soirée theme at Bal du Lac 2004

Barbara and Russell Bowman at the 1999 event

1995 Bal du Lac co-chairs Ted and Dawn Hopkins
and Stacy and Susan Terris

Braves that was held in front of the War Memorial. While that Eero Saarinen–designed building was hailed by forward-thinking architecture aficionados, its stunning design wasn't a guaranteed calling card for the institute. A cabbie told *Newsweek*, "It looks like one of the freak things I saw at the World's Fair." Former longtime mayor Daniel Hoan deemed it a monstrosity. More telling, perhaps, was the comment from a spokesperson for the Blue Star Mothers of America, who complained, "We didn't want our memorial to be a glorified art museum."

Clearly the Friends of Art had much to do. And they did. Within months plans were under way for a gala—the Bal du Lac, now a long-established highlight on many a social calendar—with proceeds earmarked for acquisitions at the recently rechristened Milwaukee Art Center. The first Bal du Lac, with music of the Jimmy Dorsey Orchestra, took place at the War Memorial Center on August 15, 1958. Tickets were $15, inexpensive even then. But Harry Lynde Bradley, chairman of the Allen-Bradley Company, was heard to remark, "No one's going to pay $15!" Well, somebody did, because the event raised $6,500, and that fall FOA bought its first piece of work for the museum's collection: Ben Nicholson's painting *Still Life, Crystal* (1948).

After several years at the War Memorial Center, the Bal du Lac moved to the Wisconsin Club. As the FOA newsletter explained: "The Board and Committee, after numerous discussions involving head, heart, palate, pocketbook and above all, the general welfare of prospective ball-goers, came to the conclusion that, beautiful though the Lake setting may be; admirably adapted though the War Memorial Building is for festive purposes, more important for joie de vivre is the opportunity to imbibe the beverage of one's choice openly and freely. . . . We hold firmly to the belief, all legal and above-board, that any Ball is kept rolling more satisfactorily by means of the lubrication proven by centuries of trial, and no error!"

This was the era of the three-martini lunch, after all, and since the War Memorial did not have a liquor license, the party was bound to move; Friends like to have fun. In covering the 1960 event, the *Milwaukee Journal* reported: "After the 'bal' was over, all-night parties were developing. Mr. and Mrs. Lawrence P. Riesen expected up to 60 guests to swim in their pool at 859 Ravine Lane, Bayside, and a breakfast party was planned by Mr. and Mrs. Reginald Sykes, 7944 N. Beach Drive, Fox Point."

"The Bal du Lac was one of the things that made Friends of Art such fun," says Roger Boerner. "When I was president of the Art Center, Mrs. Bradley came up to me at the Bal du Lac—and this is well known to everybody—and said, 'If you can build a building to house it, I'll give you my collection.'"

Whether held at the War Memorial, the Wisconsin Club, the Milwaukee Country Club, or the Quadracci Pavilion, the Bal du Lac has always been a highly visual affair. Early on, noted industrial designer and Milwaukee native Brooks Stevens did the decor. One year the east entrance of the art museum was decked out like a luxury liner, complete with gangplank. In 1985 the theme was "Jukebox Saturday Night," and the setting included a flock of pink flamingos and a T-Bird convertible. And of course it's priceless knowing that all the wining, dining, and dancing are for a good cause. "The year my husband Jeff and I co-chaired the Bal du Lac with Lori and Kurt Bechthold," enthuses Pamela Shovers, "it was absolutely rewarding to know that the money we raised went directly to the purchase of *Edge of England* (1999) by Cornelia Parker."

Ever on the lookout for ways to elevate the profile of the Milwaukee Art Center and raise funds to support it, the Friends of Art opened a rental and sales gallery in December 1958. The project was an outgrowth of an endeavor established a few years earlier by Doud and FOA co-founder Avis Steinman, in which they had set up a rental gallery on the second floor of the Steinman Lumber Company on North Holton Street. "The board of trustees were very fine people," recalls Doud, "but I think they just wanted to have a party here and there, because they said, 'Jane, you can't rent art. Who in the world would rent art?' And I said, 'Yes we can,' and we did it at the lumber company."

"I don't think Jane had a grand plan; she went incrementally with things that were fun to do," suggests Boerner. "She was full of ideas, she knew a lot of artists, she had a great imagination, and her leadership style was to suggest ideas and let other people shine, which is a great characteristic."

Situated in the War Memorial, the new rental gallery got off to a great start, raking in $1,000 on its opening day. The FOA took a 40 percent commission on rentals (rental fees ranged from $5 to $15) and 25 percent on sales. Activity was brisk: 45 pieces were rented right off the bat, and two sold, including a still life by the nationally known Madison-based painter Aaron Bohrod. "We had wonderful Wisconsin artists," states Boerner, who helped organize the gallery. "There was John Colt, Warrington Colescott, Nancy Burkert, Bob Burkert, John Wilde. Each year there was a big opening for the new collection of the rental and sales gallery, and it was well attended. The gallery did meet some resistance from gallery owners in town. I understand that. But we were trying to help, and I don't think this minor competition hurt them."

When FOA members weren't volunteering in one way or another, they kept busy with FOA-sponsored lectures, visits to the Art Institute of Chicago, and in time, trips abroad. Soon after FOA was launched, a Men's Group was formed and met monthly for lunch. Its president, Walter E. Kroening, general manager and vice president of Capitol Court, told the *Milwaukee Sentinel* that his gang wouldn't "just eat and meet and meet and eat," and hinted at "an occasional adventure,

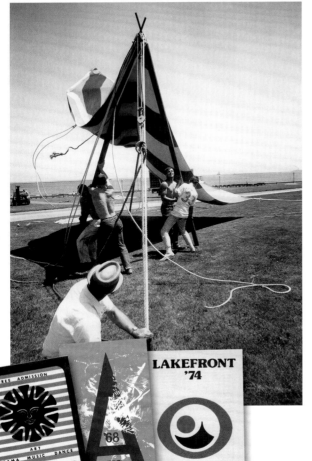

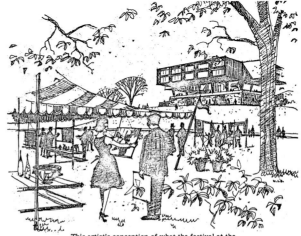

This artist's conception of what the festival at the Milwaukee Art Center will look like Saturday was drawn by architect William Guerin.

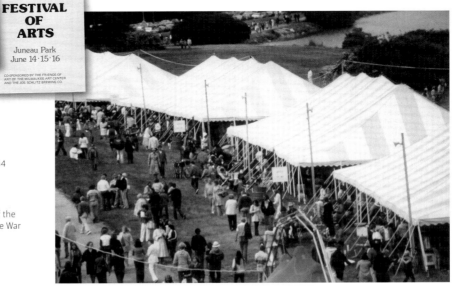

CLOCKWISE FROM TOP LEFT

Workmen erecting the tents at the 1964 Lakefront Festival of Arts

Artist William Schulman in his booth

Architect William Guerin's rendering of the grounds of the Festival of Arts, with the War Memorial in the background, 1963

Tents on the Veteran's Park site

Brochures from past festivals

a field trip to another museum or a cocktail party." Although that last remark might suggest the project was just an excuse for some testosterone–fueled bonhomie, its membership got a good earful of edification right off the bat, when Brooks Stevens spoke at the first luncheon. Meanwhile distaff Friends held their own midday get-togethers, where their guests included modern dancer Sybil Shearer and none other than Duke Ellington.

In its early years the organization kept members abreast of anything at all to do with the art center through a monthly newsletter, *Attractions*. There were listings of exhibitions, brief profiles of art center director Edward Dwight and his family ("Timothy, now eight . . . is just old enough to consider his brother a 'rambunctious noodlehead'") and reminders for the upcoming Bal du Lac ("Let's start by planning now to dress our prettiest and dance our gayest!").

For all the seeming innocence manifested in those pages, FOA quickly proved itself a serious supporter of the Milwaukee Art Center, and it would do so again and again. In 1962, inspired by the country art fairs FOA members had been participating in for years, FOA president Roger Boerner initiated the Lakefront Festival of Arts, which opened the following summer. Sited on the grounds immediately north of the Art Center, and co-sponsored by the Joseph Schlitz Brewing Company, the festival featured work by more than 130 artists in all media. Folk singers and a barbershop quartet wandered the grounds, and

Mary Maier, Helen McLaughlin, and Joan Boerner volunteer at the 1965 Lakefront Festival of Arts

there were performances by the Pick-a-Pack Players of the Fred Miller Theater, the Sunset Players, and soprano Raquel Montalvo. FOA organizers had anticipated a turnout of perhaps 10,000; 25,000 people made the scene.

With a hit on its hands, FOA brought the Lakefront Festival back, year after year. When Mayor Henry Maier arrived at a dinner announcing plans for the festival in 1968, he quipped that the event "brings a summertime association to the lakefront, other than alewives." But the popular fest wasn't always scent-free. "One year the county laid down fertilizer just before the festival," recalls Sally Birmingham, 1980 Lakefront Festival co-chair, whose first stint as a festival volunteer occurred in the late 1970s. "And then it rained, and we had this unbelievable stench— it was like springtime on the farm. Because it's a three-day outdoor festival, weather is the prevailing interest, and all of us possessed at least three pairs of throwaway shoes. I remember one year when we spent the better part of the weekend huddled in a tent, an island in a sea of mud. Ran Hoth was

the co-chair that year and wore white. And somehow he stayed pristine and fresh through the whole weekend."

One year strong winds sent a bench flying through a window of the War Memorial. In 1977 a towering helium-filled sculpture by Otto Piene (a professor of visual design at the Massachusetts Institute of Technology) was cut loose from its moorings at 5:30 a.m. by a trio of teens. Dale Faught, who has served FOA and the museum in any number of ways over 28 years, once took a sledgehammer to the head while working on the buildings and grounds crew of the Lakefront Festival. And he's still working the buildings and grounds crew today. "Over the years I've developed a lot of lifelong friendships through Friends of Art," explains Faught. "So participating has been a labor of love."

A crowd favorite, "Sidewalk Sam" Robert (Bob) Guillemin

In 1973 Tony Petullo's friend John Dunn invited him to get involved in the festival. "He said," remembers Petullo, 1977 FOA president, "'we want you to be in charge of the security guards and the people collecting the garbage.' Well, I had a lot of fun, met a lot of people. We went back to work. Then 1973 FOA president Tom Godfrey called and asked me to be co-chair of the festival. I thought: Do you know who're you're talking to? I carried garbage! I don't know that much about art. He said, 'That's okay. Neither do I.' So in '74 I did the Lakefront Festival, and that was a lot of fun. Then I got on the FOA board. That started me on an avocation as an art collector."

"The Lakefront Festival is a wonderful tradition, and it gives so much to the community," states Birmingham, who co-chaired the event with Lou Metz in 1980. "People who might be intimidated coming to the art museum or going into a gallery lose that fear, because they're outdoors and free to roam and free to look at the artwork and free to ask questions of the artists, who are right there."

A regular family affair, the Lakefront Festival of Arts has always welcomed children with a variety of kid-friendly activities. "My girls grew up at Lakefront," says Faught. "After college, my youngest daughter got involved with me on the buildings and grounds crew. She moved to North Carolina this year, but she came back for the festival. She was still on the buildings and grounds crew. We wouldn't let her off the hook." Faught's older daughter, attorney Catherine Faught, has sat on various committees as well and now serves as a legal adviser to FOA. "My youngest son and

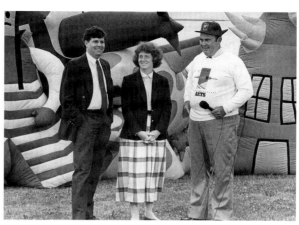

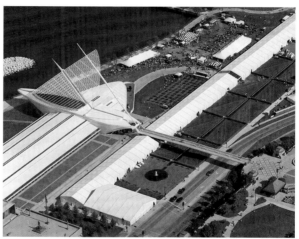

COUNTER-CLOCKWISE FROM TOP LEFT

Artist at 1975 Lakefront Festival of Arts

1995 LFOA co-chairs Claudia Francis and Mary Van Volkinburg

Children have always received special attention at the festival

The festival moved to the grounds in front of the Museum's Quadracci Pavilion in 2003

Russell Bowman with Nancy Bell and the *Today Show's* Willard Scott doing a live broadcast at the 1987 art festival.

his wife were married in June, and they have always made it a tradition to go to Lakefront and buy a piece of art as their anniversary gift to each other," offers Birmingham. "And this year, having moved out of the starter house into the bigger house, they deposited their children with me and went down and bought three pieces of art. I was thrilled to hear them say, 'You've got to watch the children, we're going down to buy art.'"

For all the camaraderie the Lakefront Festival engenders, as with all FOA events, its purpose is to encourage an appreciation of art and raise funds for the Milwaukee Art Museum. And raise money it does. The Lakefront Festival is one of FOA's most significant moneymaking endeavors. It's also FOA's most popular event, attracting a crowd of approximately 30,000 in 2007. "Years ago," notes Boerner, "there wasn't a lot of opportunity to participate in things relating to art or the art

1970 Antiques Show

museum or the collection of art. The Art Center board had, I think, 12 people. They were primarily sophisticated collectors, people who had enough cash to buy art and establish their own collections and pretty well support the art center among themselves, without having to have a major fund drive to support growth. Back then the art center's fund drives were every three years. In the interval everybody forgot about the art center, and they had to start from scratch."

Reviewing the number of FOA activities over the years, it's difficult to believe anyone could ever lose sight of the museum. In 1966 FOA launched an antiques show at the Villa Terrace Decorative Arts Museum and raised $15,000. And whether an event made money or not, it enhanced the status of the museum and made Milwaukeeans feel that they were a part of it. "One event we had," recalls 1972 FOA president Reva Shovers, "was called 'Family Flings,' where we tried to encourage families to bring their children. So once a month, on a Sunday, we'd have local artists come and do workshops with all the kids and they made something out of clay, or painted a picture or made a drawing— all kinds of things. Another thing we did was a kite fly. I found this old gentleman who made kites, Mr. Mott, and we decided we'd have kite flying. People came and made kites and flew them on the lakefront."

In the 1970s FOA co-sponsored River/Life Week, a celebration of activities along the river, and Mason Street Jazzspan, noontime concerts on the Lincoln Memorial Bridge. In 1980 the Milwaukee Art Center was renamed the Milwaukee Art Museum, and FOA activities continued apace.

In 1982 FOA organized a phonathon for the Museum's Membership and Operating Fund Campaign. The following year the group hosted an autumn masquerade ball—Art D. Skyzed—in which guests dressed as their favorite work of art. The Business of Art, a luncheon lecture series, debuted in 1984. First to speak was Quad/Graphics founder Harry Quadracci, who talked about his philosophy of having art in the workplace.

"In 1986," says Faught, "we came up with a fund-raiser event called Art Cart Caper, patterned after an event that had been done in San Francisco for many years. Sponsors paid for artists to create unique moving pieces of art. I always remember, someone showed up with three giant square wood boxes, and inside each box they put a person. And they all had to roll down Lincoln Memorial Drive in those square boxes. It was hysterical. And someone else came up with a cart that they lit on fire, and it burned as it went downhill."

The 1980s also saw "Rousseau on Toe," a collaboration with the Milwaukee Ballet, and the birth of the Grape Lakes Food & Wine Festival. The four-day do begins with a 5K run (or two-mile walk) and features a Collectors' Wine Tasting and Auction; the Wine and Dine gourmet evening, with nine courses prepared by different chefs (and each dish paired with a different wine); and the popular Grand Tasting. For years the auction was led by Michael Davis of Christie's, now a partner in Chicago's Hart Davis Hart Wine Company. "But about five years ago," explains longtime festival volunteer Dan Nelson Sr., "Michael was coming in from New York City the evening of the auction, and a hurricane blasted New York and he couldn't get here. We are now one hour before the auction without an auctioneer. So I said, 'Well, I've been to a lot of auctions, I'll give it a shot.' In any case, the auction went off, we set a record for sales, and ever since I've become the auctioneer. Every year has been a record, and I'm having fun with it. Maybe when I retire I can become a professional wine auctioneer."

Sipping a grand cru while supping on first-rate fare is swell, but even FOA gourmands will admit that sensual pleasure pales in comparison to the satisfaction of being able to add to the Milwaukee Art Museum's collection. When FOA was founded, its primary purpose was simply to get people in the door. But very shortly the organization added art acquisition to its mission. Following its purchase of the Nicholson canvas in 1958, FOA quickly acquired sculptor Henry Moore's *Woman on Steps (Figure on Steps)* (1956). In 1963 FOA spent $18,000 for a 15th-century altarpiece by an artist identified simply as the Siresa Master. "I think the audience that came to the unveiling thought we had bought something by an Abstract Expressionist," recalls Boerner. "But when the diptych was revealed, it was to enthusiastic applause."

CLOCKWISE FROM TOP RIGHT

1991 Grape Lakes attendees Jim Youker, Sally Youker, Bill Manly, Lise Lawson, and Ed Hashek

Dan Nelson (right), auctioneer for the Grape Lakes wine tasting and auction, with attendee

Grape Stomp volunteers Catherine Faught, Kim Muench, Dale Faught, and Carole Faught

Chardonnay (Sandy Lewis) and Cabernet (Rebecca Rohan)

Runners leave the Grape Stomp starting line in front of the Museum

No matter what sort of work FOA has acquired for the collection—and its gifts have ranged from an 18th-century looking glass to Duane Hanson's disturbingly lifelike *Janitor* (1973)—there's no pleasing everyone. In 1958 writers sparred over modern art in letters to the *Milwaukee Journal*. Said one anonymous "ADMIRER OF TRUE ART":

> *Those botches seem to express the twisted mentality of a so-called artist....*
> *The painter (not artist) will say I and other critics don't understand such*
> *paintings. Of course I don't! Neither does anyone else who appreciates fine,*
> *legitimate art, which portrays the beauty and sincerity of the subjects.*

Art student Roseanne Niemyt responded:

> *I wonder what our "Admirer of True Art"... holds as "fine, legitimate art."*
> *Probably some sentimental calendar landscape! Those modernistic daubs, as*
> *he calls them, happen to be an expression of the 20th century.... I say thank*
> *goodness for that "monstrous" art center and thank goodness for the*
> *"botches of mentally twisted artists" such as Braque, Picasso, and Matisse.*

Everyday Milwaukeeans weren't the only ones to give modern art a going-over. Just months after those *Journal* letter writers expressed themselves, an alderman suggested that the Common Council eliminate the Art Institute from its budget. "I can't understand those paintings and I can't understand why the city should pay money to hang them," he protested. Happily his proposal did not pass.

Folks find their way to FOA in various ways. "My parents, Kneeland and Jane W. Godfrey, were quite involved with the Milwaukee Art Center and had chaired one of the early Bal du Lacs," offers Tom Godfrey. "When my father died in 1970, someone asked me to be on the board and to be president of FOA. I told Tracy Atkinson, who was art center director at the time, that I didn't know anything about art, and he said, 'That's just fine.' So I became president and really enjoyed it. Friends of Art was dominated by a lot of beautiful women. I kind of liked that."

Pamela Shovers got hooked up through then FOA president Judy Hansen. "We were both in the Junior League, and she encouraged me to get involved. So my husband and I ended up volunteering on Lakefront for a number of years. Then I got called out of the blue; 'How'd you and Jeff like to chair the Grape Lakes Food & Wine Festival?' So I sat down with Judy and said: 'Let me get this straight. It's a four-day event, and Jeff and I have never been to this event. And you want us to chair it?' Well, we signed on."

Looking back at his extensive FOA association, Faught relates:

"I was transferred to Milwaukee from Chicago in 1979. One of the guys in the office—Price Waterhouse—said to me, 'We got this little art thing going on at the museum and we're in charge of counting the money. We drink a little beer and count a little money and have a good time. Wanna come?' So I went down, and the rest, as they say, is history. The next year I went back and did the finance thing, and by the third year I was the finance chairman. I chaired the finance committee for a number of years and then moved on to chair other committees: the entertainment committee and the food and beverage committee. Around 1987 I was asked to join the Friends of Art board. I served on the board until, gosh, I think until 2002."

That kind of commitment isn't unusual with FOA. There are any number of Lakefront volunteers, for instance, who've been doing what they do for 30 years. "Friends of Art has really had remarkable staying power in this community," observes Reva Shovers (Pamela's mother-in-law). "That's rather surprising, because society changes quite a bit. Things go up and down, but this has always been an entry to the museum. And FOA members, who may have become involved because they were interested in the kind of people that were in FOA, have gone far beyond that. They've become collectors and trustees, committee chairs, really active advocates for the museum over time. And on top of that, I think, Friends of Art spawned other groups that support acquisitions— the Contemporary Art Society, the Fine Arts Society, and the Photography Council. And Friends of Art is still full of excitement and creative energy and searching for new ways to be an important partner of the art museum."

"The richness of FOA has been the tying together of different ages, different backgrounds, and different professional skills," observes Birmingham, whose volunteer work led to staff positions at the museum in development and special events. "We've benefited from including people in our committees who had public relations or marketing or advertising skills. And the corporate connections some of these individuals had were a real bonus. A company like Northwestern Mutual, for example, was so impressed with some of the staff being involved in FOA that they became sponsors. And I attribute any kind of events and management skill I may have accumulated to having started out with Friends of Art."

"The Friends of Art is perhaps the primary source for bringing people to the museum for the first time," muses Tony Petullo, longtime museum trustee and 1977 FOA president. "Friends of

Art is the human side of the museum. If you just go to an exhibition, there's no one there who treats you like family. But the Friends of Art has all these activities during the year. And by attending or participating in some of those activities, you get to meet the family. And the museum begins to look like a home. The museum begins to look like family. That's what the Friends of Art does. It's about more than buying art for the collection; it's about giving the museum a human side."

"The FOA does a lot of 'friend raising,' as it were," says former Milwaukee Art Museum director Russell Bowman. "Events like the Bal du Lac and the Grape Lakes Food & Wine Festival allow a lot of people who don't usually interact with the museum to do so on a fun basis. Huge numbers of people would come down for the Lakefront Festival and stay to see the collection. The events the FOA organizes—and they are staggeringly effective in their organization—are a very big part of the public face of the museum."

A museum without a public face, a smile to get people in the door, is useless to a community. And a museum with little to show might just as well close up shop. For museumgoers accustomed to blockbuster exhibitions, top-notch gift shops, and appetite-appealing cafés, it's nearly impossible to realize that, well into the 20th century, many museums were forbidding institutions, havens for the elite, not the hoi polloi. Their collections were often the indiscriminate cast-offs of a city's leading citizens. And even collections that

Pamela Shovers, Isabelle Polachek, and Jeffrey Shovers attend Bal du Lac, 1999

comprised outstanding works grew slowly. While the Milwaukee Art Museum has had some stupendous donations over the years—the Bradley collection of modern European and American art, the Marcia and Granvil Specks Collection of German Expressionist Prints—when Friends of Art was founded in 1957, the museum's holdings centered on the late nineteenth-century works assembled decades earlier by meat-packing mogul Frederick Layton. As Barbara Brown Lee, the museum's long-serving educator, recalls: "There was absolutely no line item in the budget to buy art. Nada. That wasn't a part of the mentality of the boards of most museums. That's where you have people like Jane Doud entering the picture and getting things done."

The millions of dollars FOA has raised over the last 50 years have impacted every aspect of the museum's collections, from old masters to photography. Today FOA has an acquisitions committee that meets with the museum's director and curators to hear what they feel the collection needs. But in the old days the entire FOA membership was welcome to pass judgment on what the

museum's professionals had selected for acquisition. As *Attractions* explained to members in its November 1961 issue: "It's Harvest Time in Old Milwaukee! On Monday evening, Dec. 4, you will reap your reward for services rendered in the form of casting your vote for FOA's gift-of-the-year to the Milwaukee Art Center. Polish your eye-glasses, sharpen your perceptions, read up on what's what in the art world so as to prepare for the moment of impact." The voting was preceded by dinner at the University Club, after which Friends adjourned to the Milwaukee Art Center, where director Edward Dwight and a panel that included artist and Layton School of Art director Edmund Lewandowski evaluated the three works under consideration "absolutely without fear or favor."

In preparation for the 1960 purchase, a vote had been taken among FOA members to determine what type of work they wished to see their funds directed toward, and as the *Milwaukee Sentinel* noted, "a decided preference for a traditional painting" ruled the day. "I don't quite know what they mean by 'traditional painting,'" Lewandowski told a local reporter. "Personally, I would prefer a work of the last 30 years, but the choice should depend on the painting and its relation to the collection." When the votes were cast, *Portrait of Two Children* by Henri-Pierre Danloux beat out *Still Life with Fruit*, a work by 18th-century Spanish painter Luis Meléndez.

In those early decades, when museum practice had yet to become as professional as it is now, acquisitions sometimes came about in curious ways. When director Tracy Atkinson's proposal to purchase a portrait by Gustave Courbet met resistance, Roger Boerner and 14 other people formed Art Appreciation Inc. "We each put in a few thousand dollars, and we purchased the Courbet with the idea that if the art center eventually raised enough money to buy it from us, we would sell it at the price we'd paid," explains Boerner. "This would not have happened if it had not been for the forum of FOA that got us together and gave Tracy a place to go and talk about things he was unable to do directly through the board." Eventually the art center bought the picture, but this renegade group didn't remain in business for long. "We went to visit galleries in New York a couple of times, and that was great fun, but we couldn't agree on a single painting," admits Boerner. "One we wanted to buy, a piece by Gino Severini, was bought by the Tate in the time it took us to make up our minds. Tracy wasn't sure that buying art for speculation was something he ought to encourage anyway."

"When I was president of FOA in 1972," reveals Reva Shovers, "it was a little different in that I went to New York with Tracy and the two of us decided what we were going to present. That changed. The organization became larger, the board became larger, and in the end that was probably not the most professional way to do it. But the museum was much smaller then as well. The two most outrageous things we brought back were a very large Claes Oldenburg called *Trowel—Scale A 3/3* (1970), which stands in a giant pot of dirt, and Duane Hansen's *Janitor*. At first, people were just

appalled by the Hansen when we presented it. They couldn't understand it. But I would say it's become one of the more popular pieces in the museum."

Bowman's selections sometimes took FOA members aback as well. His passion for folk art wasn't always shared by the acquisitions committee (though they never nixed his wishes), and his eye for contemporary art was periodically underappreciated. "They still kid me about Joseph Kosuth's *One and Three Hammers* (1965), a conceptual work of art which is a picture of a hammer and the dictionary definition of the word. I think what I learned from that experience was that if FOA had a better sense beforehand of where the museum was headed, then we were likely to accomplish matters with a good deal less anxiety. So we made up what I called 'want lists.' We'd look at the collection, see what it lacked, and if we found one of those things and presented it to FOA, it didn't come as a complete surprise. But I also always told FOA to be prepared for a surprise. Because somewhere a curator will be out in the galleries, at an art fair or auction, and see something they didn't have on the list that seems to be just the right thing." Looking back at her days as FOA president and Bowman's enthusiasm for expanding the collection, Judy Hansen laughs, "It's funny how Russell Bowman always showed up right after a special event!"

Now a private consultant and dealer in Chicago, Bowman salutes the Friends of Art not only for its fund-raising prowess but also for its willingness to direct those funds in ways most advantageous to the museum. "In 1993," relates Bowman, "we acquired a Jasper Johns painting for $1 million. It was the most expensive single acquisition that we had made. That acquisition was made possible by three separate groups: FOA, the Virginia Booth Vogel Acquisition Fund, and the Contemporary Art Society. It was always a point of discussion in FOA; 'Well, we've gone through all these efforts to raise this money, should the acquisition carry just our name? Are we diluting the recognition of our efforts by sharing a credit line with others?' But FOA was willing to share, and that set a precedent that was important for some of those other funds and acquisition groups. And this was a case where it was very important that they were willing to do that, because that painting could not have been acquired by any of the three groups alone."

Not only did FOA demonstrate a cooperative spirit in the Johns purchase, but it made a multiyear commitment, devoting $450,000 over two years to the acquisition. It made similar commitments in the 1990s, when it threw its weight behind the acquisition of the Michael and Julie Hall Collection of American Folk Art and three works by painter Robert Motherwell. One of FOA's more unusual projects was joining with several private and public entities—including the National Endowment for the Arts, First Milwaukee Bank, and the Marcus Corporation—to realize Richard Haas's enormous trompe l'oeil mural on the Centre Theater Building downtown.

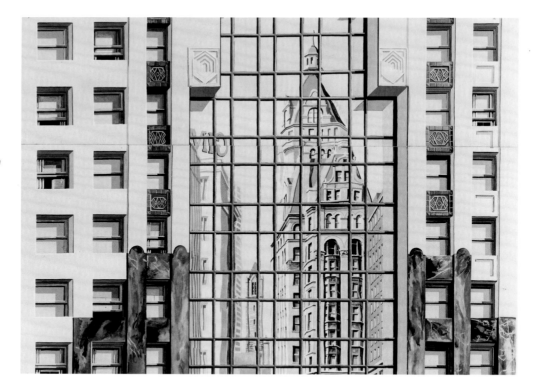

Richard Haas, *Presentation Drawing for Design for Centre Theater Building, Milwaukee*, 1981 (detail) (page 75)

A survey of FOA's contributions to the Milwaukee Art Museum's collection reveals how significantly the organization has helped the museum become the treasure house it is. And every curatorial department has benefited. One of FOA's earliest gifts was Franceso Solimena's *Madonna and Child with St. Januarius and St. Sebastian* (ca. 1700), a large late Baroque altarpiece whose scale advances its essential pathos. A silver coffeepot from 18th-century Philadelphia silversmith Thomas Shields, a streamlined vessel with a tastefully articulated spout, is one of the finest examples of his craft. A reclining chair by the Bauhaus-trained modernist Marcel Breuer (renowned as designer of the tubular steel Wassily chair and architect of the Whitney Museum of American Art) is an aluminum piece with a steep pitch in the seat to bring a sitter's knees up and a perfectly angled back to further guarantee repose.

Thanks to FOA, visitors to the museum can see key paintings by Ad Reinhardt, Robert Motherwell, Susan Rothenberg, and David Salle. Leading postwar German artist Anselm Kiefer—whose dark, rough-surfaced canvases often reference his nation's complex history—is represented in the collection by *Midgard* (1982–85), a large-scale work that takes a Norse legend as it starting point but remains open to interpretation. Depicting a can of Pabst and a bowling ball, Tom Wesselmann's *Still Life #51* (1964) seems tailor-made for Milwaukee, even as we fight the old stereotypes.

FOA additions to the museum's photography collection range from a grim shot of Gettysburg (from Alexander Gardner's *Photographic Sketchbook of the Civil War*) to the blunt, unmediated urban images of Walker Evans and the masterfully composed landscape studies of Ansel Adams. Edward Steichen's portrait of his wife, painter Georgia O'Keeffe, which entered the collection in 1952, is a seemingly simple, straight-on shot, in which the artist looks directly at the camera with a Mona Lisa smile.

The prints and drawings collection has been immensely enriched by works by Sol LeWitt, Philip Pearlstein, Joseph Stella, and outsider artist Martín Ramírez. Romare Bearden's collage *The Street* (1964) may echo the influence of his teacher George Grosz (whose own work so often delineated public life in urban spaces), but it exhibits an explosive dynamism and a pictorial freedom all its own. American Brice Marden's *Cold Mountain Series, Zen Study 3*, from the early 1990s, is an almost calligraphic image made with sticks dipped in a sugar solution and drawn across etching plates with an aquatint ground. Following its early gift of a bronze by Henry Moore, FOA has augmented the museum's sculpture holdings with pieces by Alexander Calder, Robert Irwin, and George Segal, among many others.

Beginning in 1985 FOA expanded its role when it underwrote *Mark Rothko: Works on Paper*, the first of many exhibitions it would bring to the museum. Whether acting as sole sponsor or part of a funding team—as with 2007's *Pissarro: Creating the Impressionist Landscape*—FOA has greatly assisted the museum in realizing its responsibility to bring top-quality shows to Milwaukee. In 2001 Friends of Art added yet another level of support to the museum when it committed $500,000 to the capital campaign for the building of the Calatrava addition, a gift that would eventually total $1 million.

As the museum's largest volunteer fund-raising group, Friends of Art has had a profound impact, not only on the museum's holdings but also on the way Milwaukeeans regard their museum. Whether it's the crowd-drawing Lakefront Festival of Arts or the smaller-scale Christmas and holiday sale, Ornaments & Adornments, Friends of Art has succeeded in creating an array of public-pleasing events, each of which reinforces the presence of the Milwaukee Art Museum as an incomparable community asset. Jane Doud and those first volunteers were resolutely tireless, and as a result, the Milwaukee Art Museum is a far cry from the institution they first nurtured 50 years ago. With more than 3,000 members today, and the same unflagging commitment first demonstrated in 1957, Friends of Art will continue to shape the Milwaukee Art Museum for generations to come.

Friends of Art Presidents and Committee Co-Chairs

Presidents of FOA

	
2006–07	Ed Hanrahan
2004–05	Lori Bechthold
2002–03	Pamela Shovers
2000–01	Stacy Terris
1998–99	Lise Lawson
1996–97	Dale Faught
1994–95	Judy Hansen
1992–93	Dwight Ellis
1990–91	Ed Hashek
1988–89	Bill Manly
1987	Nancy Bell
1985–86	Rick Fumo
1983–84	Ran L. Hoth
1982	Susan Godfrey
1981	John McGregor
1980	Polly Beal
1979	Steve Dragos
1978	Katie Gingrass
1977	Tony Petullo
1976	Susan Oster
1974–75	Caryl Sunshine
1973	Tom Godfrey
1972	Reva Shovers
1971	Bob Ornst
1970	Pat Apple
1969	Don Hevey
1967–68	Jack Lewis
1966	Mary Ellen Philipp
1965	Lloyd Herrold
1964	Beulah Donohue Hochstein
1963	Lath Hall
1962	Roger Boerner
1961	Jules Joseph
1960	Viola Lomoe
1959	Walter Kroening
1958	Avis Steinman
1957	Jane Doud

Bal du Lac

Year	Co-Chairs
2007	Joe Massimino, Holly Segel
2006	Heidi and Harry Mains, Trish and Joe Ullrich
2005	Molly Allen, Kristin Severson
2004	Susan and Robert Forrer, Ellen and Hans Kirkegaard
2003	Marie-Pierre and David Bechthold, Colleen and Gene Jacobus, Gail and Gary Reynolds
2002	Holly and Justin Segel
2001	Dacy and Chris Abele
2000	Lori and Kurt Bechthold, Pamela and Jeffrey Shovers
1999	Lise and Tom Lawson, Judy Russell, Howard Bornstein
1998	Janet and Bill Gebhardt, Wendy and Tom Gebhardt
1997	Sheila and Steve Chamberlin, Diane VanDerhei, Bill Kissinger
1996	Gaylynn and Paul Weaver
1995	Dawn and Ted Hopkins, Susan and Stacy Terris
1994	Janet R. and Tim Ryan III
1993	Carole and Dale Faught, Doris and Ed Heiser
1992	Lori and Bruce Gendelman
1991	Donna and Donald Baumgartner, Dorothy and James Stadler
1990	Jodi Peck, Les Weil
1989	Melodie and Wayne Oldenburg
1988	Clarie and Bob Milbourne, Sue and Bud Selig
1987	Jane and Frank J. Pelisek
1986	Vicki and Allen Samson, Pat and Paul Vogelsang
1985	Joyce and Nick Pabst, Karen and Ken Parelskin
1984	Jill and Jerry Polacheck, MaryGail and Arthur Py
1983	Ellen and Dick Glaisner, Bonnie and Leon Joseph
1982	Peggy and Nat Bernstein, Suzy and Ron Walter
1981	Barbara and Steve Becker, Andrea and Dennis Frankenberry
1980	Pam and Justin Segel, Marilyn and Russell Larry Smith
1979	Elaine and Ran Hoth, Judy and Bert Litwin
1978	Susan and Tom Godfrey, Susan and Joel Lee
1977	Barbara and Jack Recht, Andy and Camp Van Dyke
1976	Rosemary and Dick Fritz, Peg and Henry Jones
1974	Betsy and John Lierk, Judy and John McGregor
1973	Linda and Gary Grunau, Marilyn and Allen Taylor
1972	Nancy and John Koss
1971	Marilyn and Brad Bradley
1969	Carolyn and Dick Jacobus
1968	Mary and Ed Williams
1967	Barbara and John Luthe
1966	Nancy and Bob Greenbaum
1965	Pat and Ross Anderson
1964	Richard Muenzner, Jerri Weiss
1963	Richard Harrington, Jean Smith
1962	Kneeland Godfrey, Anita Hinrichs
1961	Roger LeGrand, Molly Sykes
1960	Joy and Bob Christiansen
1959	Mimi Stack, Fritz von Grossmann
1958	Betty Servis, Jack Syvertsen

William Manly and Joyce Pabst

Lakefront Festival of Arts

2007	Jen Dirks, Larry Oliverson
2006	Deb Fabritz, Tim Garland
2005	Carole Faught, Pamela Shovers
2004	Nancy Munroe, Holly Schoettlin
2003	Julia DeCicco, Larry Schnuck
2002	Valerie Clarke, Bob Wolf
2001	Bill Manly, Arlene Wesson
2000	Andrea Frankenberry, Ed Hashek
1999	Martha Moore, Kim Muench
1998	Eilene Stevens, Kim Wilson
1997	Dwight Ellis, Kathy Wolf
1996	Lori Bechthold, Bill Warner
1995	Claudia Francis, Mary Van Volkinburg
1994	Rhonda Rutzen, Steve Kessel
1993	Carl Schmidt, Sue Sweeney
1992	Patty DeJong, Lou Metz
1991	Peggy Jacobson, Robert Rutzen
1990	Dale Faught, Anne Harris
1989	Jim DeJong, Judy Hansen
1988	Craig Gundersen, Mary Mulcahy
1987	Karen Spahn, Bill Warner
1986	Wayne Gerlach, Judy Rauh
1985	Jan Schmidt, Bob Wolf
1984	Candy Conlan, James Daly
1983	Nancy Bell, Jim Harris
1982	Scott Gray, Jeanne Maxon
1981	Dennis Hollman, Jackie Thompson
1980	Sally Birmingham, Lou Metz
1979	Dean DeVillers, Pat O'Brien
1978	Karen Graham, Ran Hoth
1977	Terry Hueneke, Patty Schuyler
1976	Skip Muench, Mary Stearns
1975	Gene Ackley, Diane Buck
1974	Jill Stocking, Tony Petullo
1973	John Dunn, Susan Oster
1972	Cissie Darien, Mark McGlinchey
1971	Gary Grunau, Caryl Sunshine
1970	Mike Devitt, Edie Herrold
1969	Jim Nelson, Jane Pelisek
1968	Robert Ornst
1967	John Banzhaf, Joan Boehm
1966	Jim Lewis, Joan Boehm
1965	Joan Boerner, Lloyd Herrold
1964	Jack Lewis, Mary Ellen Philipp
1963	Jack Lewis, Mary Ellen Philipp

Grape Lakes Food & Wine Festival

2007	Jon Hopkins
2006	Jon Hopkins
2005	Joe Massimino
2004	Libby and Andy Bruce, Liz and Rick Gebhardt
2003	Libby and Andy Bruce
2002	Ann Pieper Eisenbrown, Jon Hopkins
2001	Lise Lawson, Eileen Wright–Dimick
2000	Molly and Jim Allen
1999	Stephanie and Peter Fleming
1998	Jeff Dunn, Judy Russell
1997	Lise Lawson, Judy Russell
1996	Pamela and Jeffrey Shovers
1995	Lise Lawson, Larry Schnuck
1994	Ed Hashek, Paul and Danita Cole Medved
1993	Paul and Danita Cole Medved
1992	Bette Jacquart, Dan Nelson Sr.
1991	Janie Asmuth, Tim Ryan
1990	Ron Jacquart, Patti Keating
1989	Nancy Bell, Bill Krugler (with Mary Beth Carr and Pam Percy)
1988	*First year of GLFWF; FOA not involved*

Friend of the Year Award

2007	Rick Friedman
2006	Donald Baumgartner
2005	Tom Florsheim
2004	Dan Nelson Sr.
2003	Lise Lawson
2002	Russell Bowman
2001	Tony Petullo
2000	Dale Faught
1999	Ellen Glaisner
1998	Dwight Ellis
1997	Judy Hansen
1996	Dorothy Stadler
1995	Marilyn Bradley
1994	Ed Hashek
1993	Rick Fumo
1992	Bill Manly
1991	Charlotte Zucker
1990	Jean Friedlander
1989	Polly Beal
1988	George Evans
1987	Jill Pelisek
1986	Betty Quadracci
1985	Sally Birmingham
1984	Dennis Frankenberry
1983	Edie and Lloyd Herrold
1982	Don Turek
1980	MGIC
1977	Docents
1973	Ben Barkin
1972	Lucia Stern
1968	Bob Uihlein Jr.
1967	Seven Founders of FOA: Mary Lou Cook, Florence Cron, Anita Hinrichs, Virginia Jefferson, Avis Steinman, Virginia Vogel, Ester Weber
1966	Irene and Herbert Johnson
1964	Sister Thomasita
1963	Ed Fitzgerald
1962	Elliot Grant Fitch
1961	Jane Doud
1960	Emily Groom
1959	Virginia Vogel
1958	Peg and Harry Bradley

Skip Muench

Volunteer Service Award

2007 Linda Boxill, Ann Krueger, John Krueger

2006 Eric Eben, Carole Faught, Catherine Faught, Christy Metcalf

2005 Danielle Brinkman, Craig Gundersen, Scott Maslowski

2004 Chris Haines, Jim Harris, Wendy Jensen, Michaelinda Kircher

2003 Laura Brunner, Pete Hovanec, Arlene Wesson

2002 *no award presented*

2001 Andrea Frankenberry, Mary Van Volkinburg

2000 Peggy Jacobson, Larry Stadler and the MAM Technicians, Barbara and Susan Strecker

1999 Claudia Francis, Heide Kraus, Judy Russell, Bill Warner

1998 Deb Fabritz, Steve Kessel, Eilene Stevens, finance team from Price Waterhouse, staff at the Bradley Sculpture Garden

1997 Meg McCormick, Kim Muench, Perry Newsom

1996 T. J. Jensen, Kristi Kopischke—Firstar Community Involvement Program, Scott Marfilius, Kim Wilson

1995 Karen Allen, Norbert Lochowitz, Kathy Wolf, GLFWF chefs:
Knut Apitz—Grenadier's Restaurant
Edouard Becker—Ogden Entertainment & English Room
Mark Berggren—Westmoor Country Club
Rico Castillo—Palomas
Nico Derni—Elm Grove Inn & Red Circle Inn
Axel Dietrich—Harold's Restaurant, The Grand Hotel
Mirassa Dimapilis—Westmoor Country Club
Scott McGlinchey—Heaven City Restaurant
Thomas Peschong—Riversite Restaurant
Scott Shully—Shully's Events & Cuisine
Jeff Slough—North Hills Country Club

1994 Lori Bechthold, Valerie Clarke, Patty and Jim DeJong, Marguerite Gohsman, Sandy Lewis, Helen Pfeifer

1993 Kaye Geise, Martha Moore, Sue Gundersen Sweeney

1992 Virginia Clark, Donna Maher, Dick Ulrich, Bob Wolf (accepted on behalf of LFOA Building & Grounds Committee)

1991 Joyce Lefco, Mimi Mullenax, Tim Ryan, Dorothy Nelle Sanders

1990 Kay Kittell, Sally Litzow, Jan Schmidt, Jack Taylor

1989 Ron and Bette Jacquart, Jen Jensen, Janet Johnson, Chuck Sable, Nancy Wolfe, Charlotte Zucker

1988 Kathy Eggener, Shirley Enlund, Janice and Bob Eskuche, Marj Franz, Ann and Jim Harris, Gloria Moss, Annette Niedermeyer, Margo Vukovich

1987 Scott Gray, Wallace Lee, Susie McDonald, Ruth Panosh, Verna Pegalow, Way and Jackie Thompson, Milw. Institute of Art and Design Students (represented by MIAD president Terry Coffman and student rep. Brent Montgomery)

1986 Candy Conlan, Lois Ehlert, Karen Olsen, Joyce Pabst

1985 Beth Chapman, Christine Flacco, Pauline and Ken Judy, Judith Moriarty

1984 Arlene Barian, Susie Conen, Janet Fishman, Craig Gundersen, Inga and John Hinebauch, Joan Kabins

1983 Mary Brill, George Evans, Missie Hawley, Marge Pietri, Suzanne Staff, Joanne Vanderbusch

1982 "Unsung Hero Award," Rose Brojanac, Marie Caro, Elizabeth O. DeFernandez, Julie Evans, Ray Fetterley, Fran Hunter, Ruth Lauren, Lou Metz, Margaret Meyer, Eileen Millonzi, Juliane and John Mueller, Skip Muench, Ellen Pfeifer, Janet Treacy

Partner in Art Award

2007 Kahler Slater

2006 Milwaukee Magazine

2005 Wisconsin Energy Corporation

2004 Robert W. Baird & Co. Incorporated

2003 Northwestern Mutual

2002 *no award presented*

2001 Eller Media Company, Kubin–Nicholson, LAMAR Outdoor

2000 Hawks Nursery Co.

1999 BVK/McDonald

1998 Nelson & Schmidt Marketing Communications, Inc.

1997 Grenadiers

1996 Manpower Inc.

1995 Sentry Foods

1994 Midwest Express Airlines

1993 First Bank Milwaukee, N.A.

1992 Miller Brewing Company

Dorothy Nelle Sanders

Ben Barkin

A 50-Year Legacy of Art

Since its inception, Friends of Art has been instrumental in helping the Milwaukee Art Museum to create a world-class art collection. Highlights of the past 50 years are shown here, followed by a complete list containing detailed information.

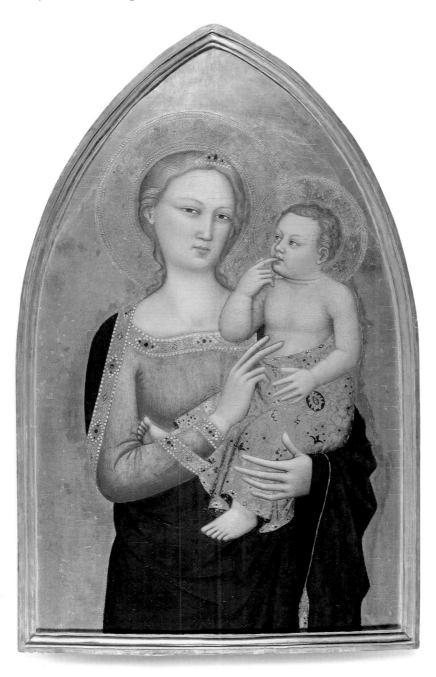

Nardo di Cione
Madonna and Child, ca. 1350
(page 73)

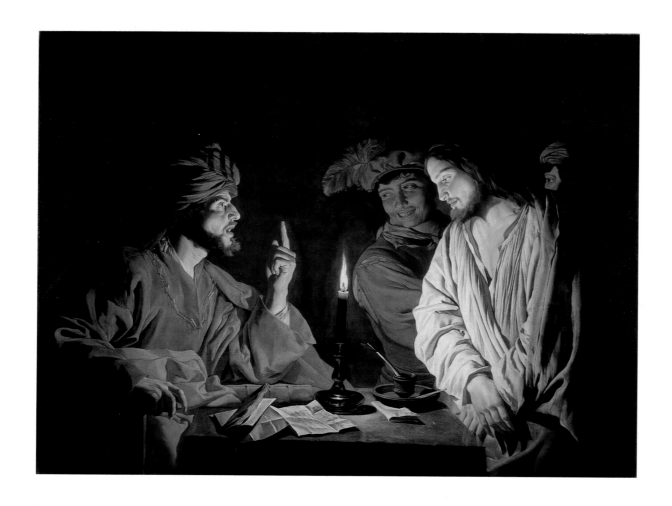

Matthias Stom, *Christ before the High Priest,* ca. 1633 (page 74)

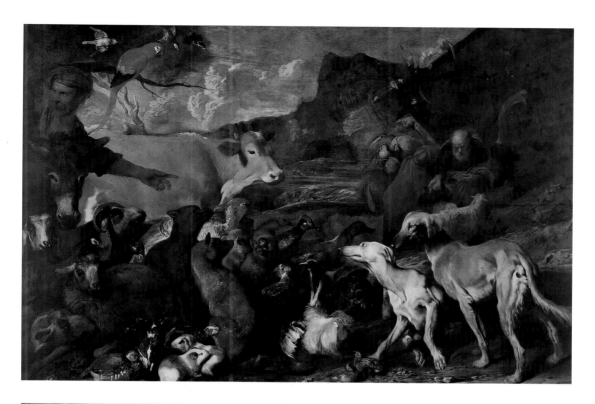

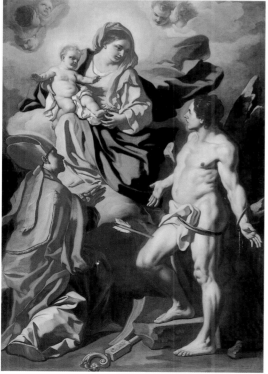

Giovanni Benedetto Castiglione, *Noah and the Animals Entering the Ark*, ca. 1650 (page 73)

Francesco Solimena, *Madonna and Child with St. Januarius and St. Sebastian*, ca. 1700 (page 73)

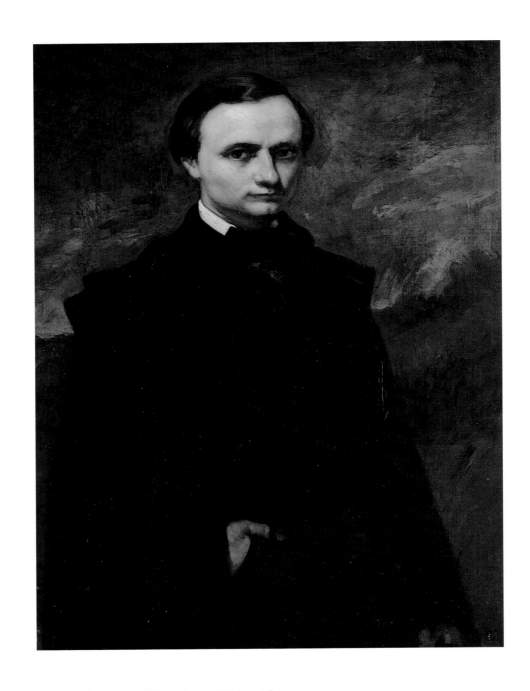

Gustave Courbet, *Portrait of Clément Laurier*, 1855 (page 73)

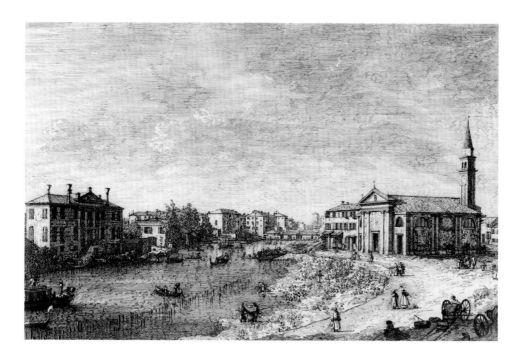

Canaletto, *View of a Town with a Bishop's Tomb*, 1741–47 (page 74)

Giovanni Battista Piranesi, *The Grand Piazza*, 1749–60 (page 74)

Paul Cézanne, *The Bathers—Large Stone,*
1896–97 (page 74)

Chuck Close, *Self-Portrait*, 1977 (page 74)

Lucian Freud, *Head and Shoulders
of Girl*, 1990 (page 74)

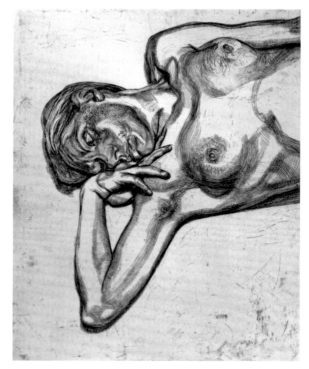

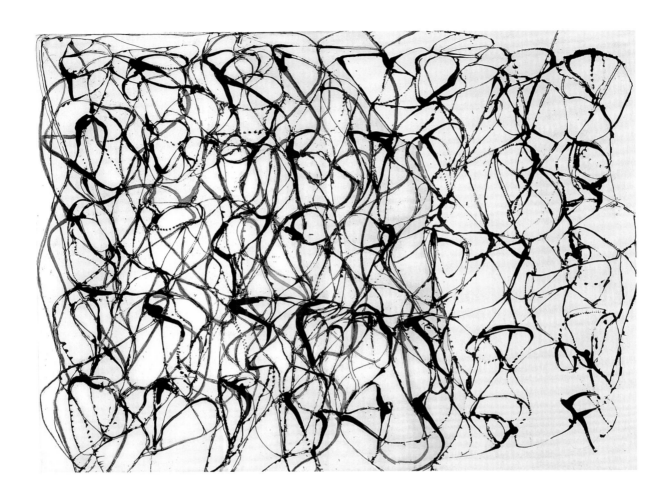

Brice Marden, *Cold Mountain Series, Zen Study 3*, 1991 (page 74)

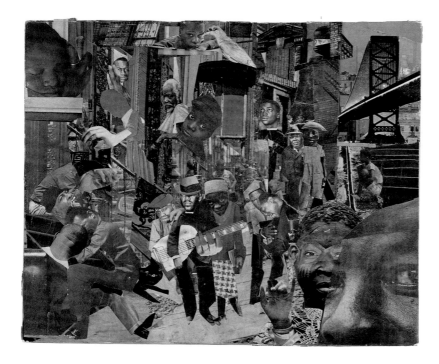

Romare Bearden, *The Street*, 1964
(pages 20 and 75)

Carlo Carrà, *Portrait of Marinetti*, 1914
(page 75)

William Kentridge, *Drawing for the Film
"Monument,"* 1990 (page 75)

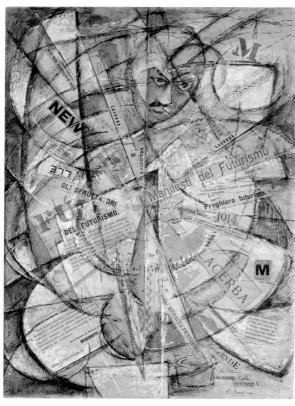

Joseph Stella, *The Quencher (Night Fires)*, ca. 1919 (page 75)

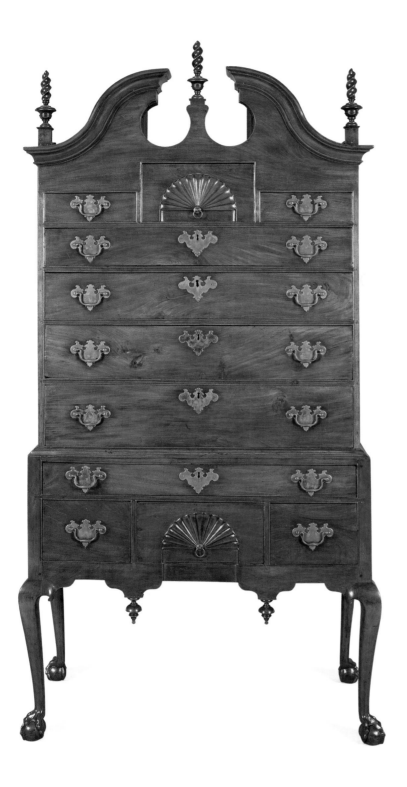

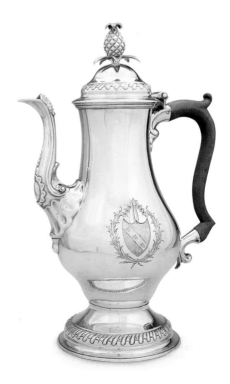

High Chest of Drawers, 1755–75 (page 79)

Coffeepot, 1765–90 (page 79)

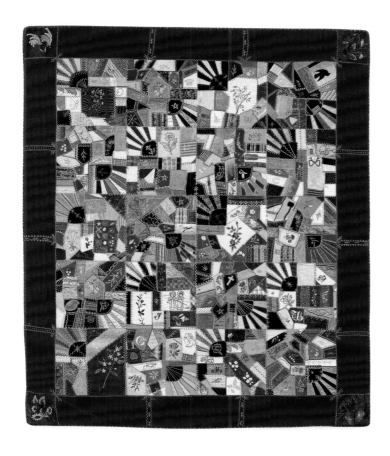

Crazy Quilt, 1883 (page 79)

Sewing Desk, ca. 1850 (page 79)

John Bard and James Bard, *The Steam Ferry "Highlander,"* ca. 1835 (page 75)

José Benito Ortega, *Crucifixion*, ca. 1885 (page 78)

Eugene von Bruenchenhein, *Portrait of the Artist's Wife, Marie (Seated)*, ca. 1940s (page 77)

Eugene von Bruenchenhein, *Crown*, late 1960s (page 78)

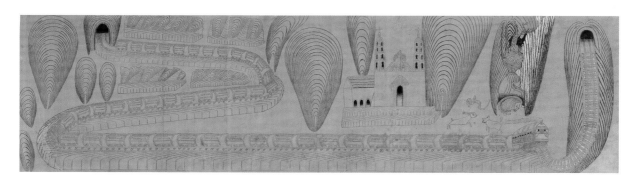

Martín Ramírez, *Untitled (Landscape with Train, Church, and Animals)*, ca. 1950s (page 75)

Michael Lenk, *The Fifth Day of Creation*, ca. 1965 (page 75)

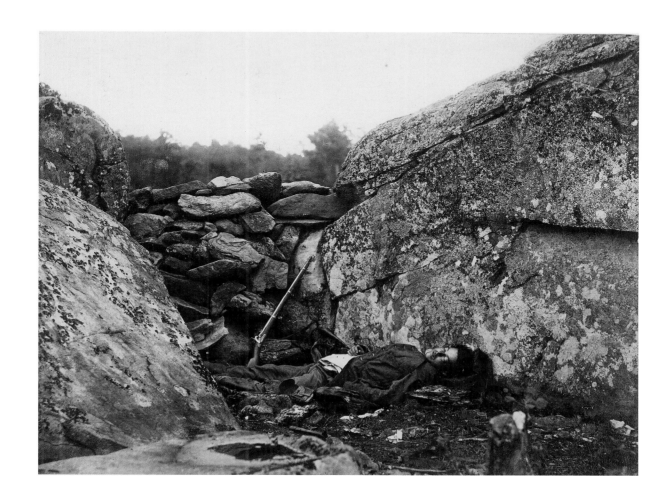

Alexander Gardner, *Dead Confederate Soldier at Devil's Den, Gettysburg, July 6, 1863*, 1863 (page 76)

Paul Strand, *House of a Fisherman, Vera Cruz, Mexico*, 1934 (page 77)

Berenice Abbott, *Blossom Restaurant*, 1935 (page 75)

OPPOSITE

Walker Evans, *Couple at Coney Island*, 1928 (page 75)

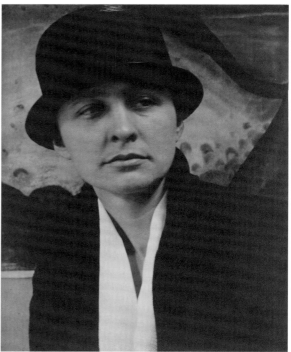

André Kertész, *Satiric Dancer*, 1926 (page 76)

Alfred Stieglitz, *Portrait of Georgia O'Keeffe*, 1918 (page 76)

Ansel Adams, *Moonrise, Hernandez, New Mexico*, 1941 (page 75)

Garry Winogrand, *San Marcos, Texas*, 1964 (page 77)

Cindy Sherman, *Untitled*, 1985 (page 76)

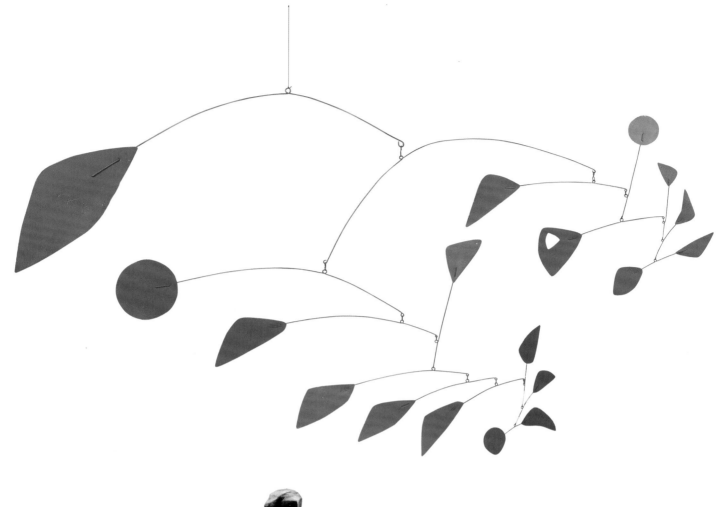

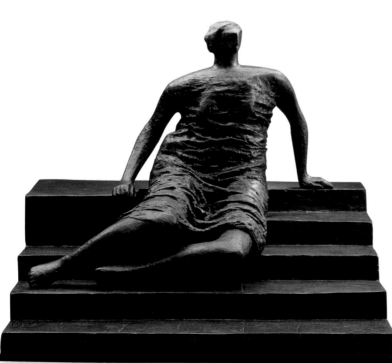

Alexander Calder, *Just a Sumac to You, Dear*, ca. 1965 (page 78)

Henry Moore, *Working Model for Draped Seated Woman: Figure on Steps*, 1956 (page 78)

OPPOSITE
Eva Hesse, *Right After*, 1969 (page 78)

Robert Morris, *Untitled*, 1970 (page 78)

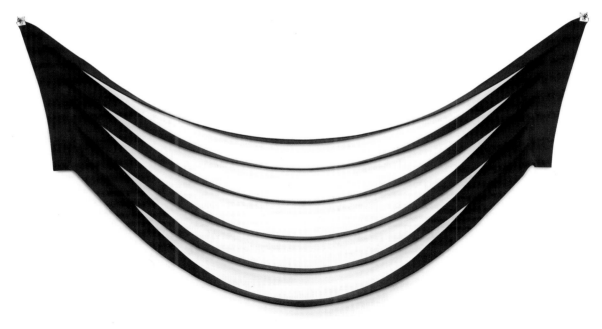

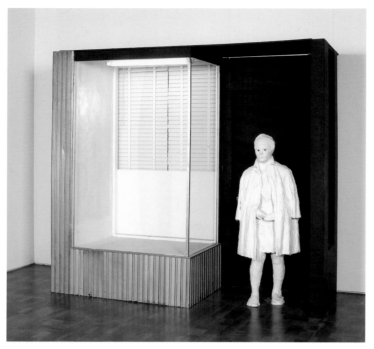

George Segal, *The Store Window*, 1969 (page 78)

Claes Oldenburg, *Trowel—Scale A 3/3*, 1970 (page 78)

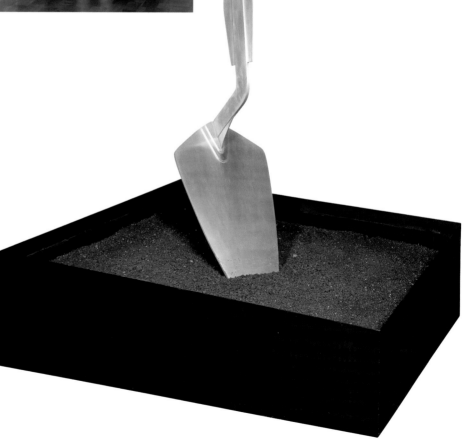

Sol LeWitt, *Wall Drawing #88 (Wall Drawing for the Milwaukee Art Center)*, 1971 (detail) (page 75)

Duane Hanson, *Janitor*, 1973 (page 78)

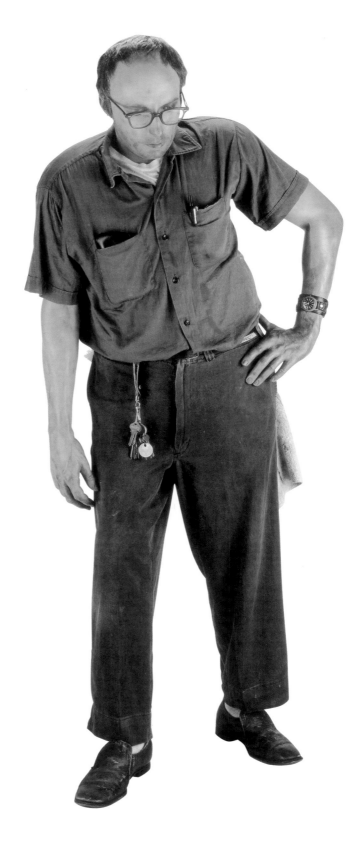

Roger Brown, *At Red Bay Waiting for "The City of Miami,"* 1976 (page 73)

Agnes Martin, *Untitled #10*, 1977 (page 73)

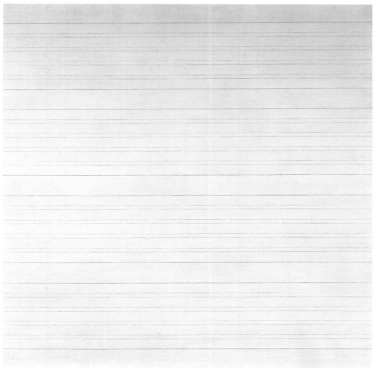

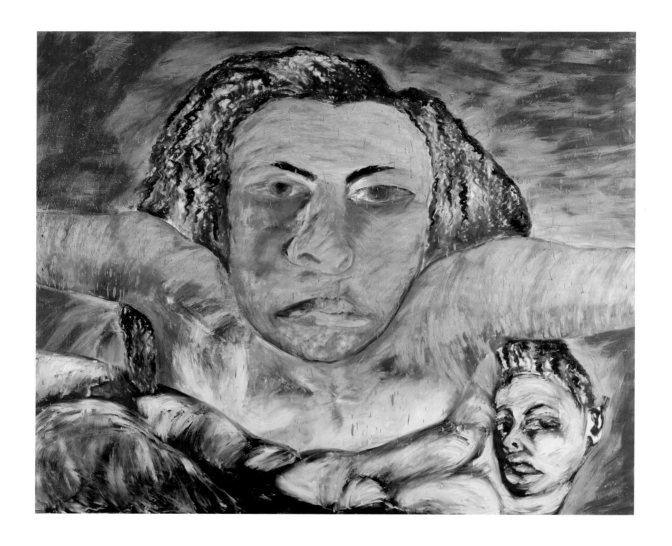

Francesco Clemente, *Untitled*, 1983 (page 73)

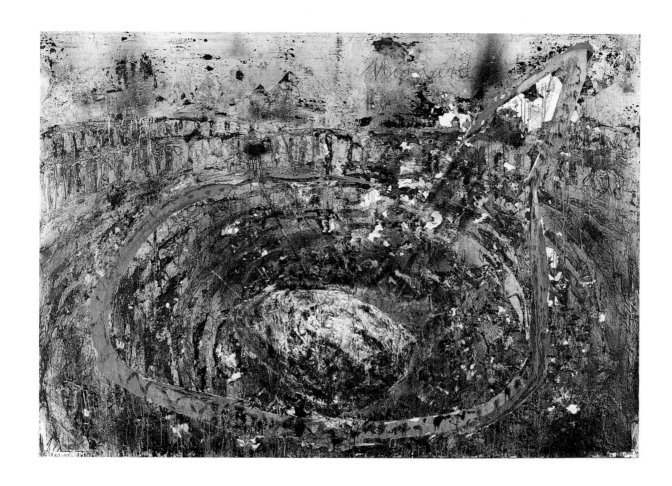

Anselm Kiefer, *Midgard*, 1982–85 (page 73)

Cornelia Parker, *Edge of England*, 1999 (page 78)

Nam June Paik, *Ruin*, 2001 (page 78)

NOTE TO THE READER

The present checklist consists of **222 artworks** purchased with funds donated by Friends of Art. The checklist is organized by medium, beginning with paintings, followed by prints, drawings, photographs, sculpture, and decorative arts. Each section is organized alphabetically by artist, except for the decorative arts section, which is chronological. Dimensions are in inches, with height preceding width and depth. All measurements for works on paper indicate sheet size; all photograph dimensions are image size. Entries for the works that are illustrated in this volume are in bold type, accompanied by the symbol ▸. In 1989 Friends of Art was a major contributor to the acquisition of the Michael and Julie Hall Collection of American Folk Art, which includes more than 270 objects ranging from 18th-century weathervanes to works by recent outsider artists. All these works were published separately in the 1993 exhibition catalogue *Common Ground/ Uncommon Vision: The Michael and Julie Hall Collection of American Folk Art.*

PAINTINGS

Jan van Amstel (Flemish, ca. 1500–ca. 1542). *Christ and the Two Pilgrims on the Way to Emmaus,* ca. 1540. Oil on wood panel. 32 x 37 ½ in. Gift of Friends of Art M1987.20.

Richard Anuszkiewicz (American, b. 1930). *Sol II,* 1965. Liquitex (acrylic) on canvas. 84 ¼ x 84 ¼ in. Gift of Friends of Art M1967.21.

▸ **Roger Brown (American, 1941–1997). At Red Bay Waiting for "The City of Miami," 1976**. Oil on canvas. 72 ⅛ x 72 ¹/₁₆ in. Gift of Friends of Art M1983.211. (See page 69.)

▸ **Giovanni Benedetto Castiglione (Italian, 1609– 1664). Noah and the Animals Entering the Ark, ca. 1650**. Oil on canvas. 47 ½ x 111 in. Centennial Gift of Friends of Art, Myron and Elizabeth P. Laskin Fund, Fine Arts Society, Friends of Art Board of Directors, Francis and Rose Mary Matusinec, Burton and Charlotte Zucker, and the Milwaukee community M1988.182. (See page 47.)

▸ **Nardo di Cione (Italian, ca. 1320–ca. 1366). Madonna and Child, ca. 1350**. Tempera and gold leaf on panel. 29 ½ x 19 in. Purchase, Myron and Elizabeth P. Laskin Fund, Marjorie Tiefenthaler Bequest, Friends of Art, and Fine Arts Society; and funds from Helen Peter Love, Chapman Foundation, Mr. and Mrs. James K. Heller, Joseph Johnson Charitable Trust, A. D. Robertson family, Mr. and Mrs. Donald S. Buzard, the Frederick F. Hansen family, Dr. and Mrs. Richard Fritz, and June Burke Hansen; with additional support from Dr. and Mrs. Alfred Bader, Dr. Warren Gilson, Mrs. Edward T. Tal, Mr. and Mrs. Richard B. Flagg,

Mr. and Mrs. William D. Vogel, Mrs. William D. Kyle, Sr., L. B. Smith, Mrs. Malcolm K. Whyte, Bequest of Catherine Jean Quirk, Mrs. Charles E. Sorenson, Mr. William Stiefel, and Mrs. Adelaide Ott Hayes, by exchange M1995.679. (See page 45.)

▸ **Francesco Clemente (Italian, b. 1952). Untitled, 1983**. Oil on canvas. 78 x 93 in. Gift of Friends of Art M1985.6. (See page 70.)

▸ **Gustave Courbet (French, 1819–1877). Portrait of Clément Laurier, 1855**. Oil on canvas. 39 ⅜ x 31 ¾ in. Gift of Friends of Art M1968.31. (See page 48.)

Henri-Pierre Danloux (French, 1753–1809). *Portrait of Two Children,* ca. 1800. Oil on canvas. 49 ¾ x 40 ⅛ in. Gift of Friends of Art M1960.49.

Attributed to Adriaen van Gaesbeeck (Dutch, 1621–1650). *An Artist in His Studio,* ca. 1645. Oil on panel. 36 ½ x 29 ¼ in. Gift of Friends of Art M1989.6.

Sam Gilliam (American, b. 1933). *Carousel Merge II,* 1971. Acrylic on canvas. 186 x 102 in. Gift of Friends of Art M1976.36.

Richard La Barre Goodwin (American, 1840–1910). *Hunting Cabin Door,* ca. 1889. Oil on canvas mounted on Masonite. 52 ⁵/₁₆ x 32 ⁷/₁₆ in. Gift of Friends of Art and Purchase, Acquisition Fund M1980.2.

Richard Haas (American, Wisconsin, b. 1936). *Centre Theater Facade,* 1981. Painted building facade, Centre Theater Building, Milwaukee. 1476 x 840 in. Gift of Friends of Art M1981.304.

▸ **Jasper Johns (American, b. 1930). Untitled, 1984**. Oil on canvas. 75 x 50 in. Purchase, Friends of Art, Contemporary Art Society, and Virginia Booth Vogel Acquisition Fund M1993.1. (See page 16.)

▸ **Anselm Kiefer (German, b. 1945). Midgard, 1982–85**. Oil, emulsion, and acrylic on photographic linen on canvas. 110 x 149 in. Gift of Friends of Art M1987.1. (See page 71.)

Lawrence Lebduska (American, 1894–1966). *Hit-Mu-To (Hitler-Mussolini-Tojo),* 1942. Oil on Masonite. 25 ⅞ x 32 ¼ in. Gift of Friends of Art M2002.9.

▸ **Michael Lenk (American, Wisconsin, 1890–1982). The Fifth Day of Creation, ca. 1965**. Acrylic on canvas. 31 ¼ x 35 ¼ in. Gift of Friends of Art M1999.27. (See page 58.)

▸ **Agnes Martin (American, b. Canada, 1912–2004). Untitled #10, 1977**. Gesso, India ink, and graphite on canvas. 72 x 72 ⅛ in. Gift of Friends of Art M1981.6. (See page 69.)

▸ **Ludwig Meidner (German, 1884–1966). Portrait of a Young Man, 1912**. Oil on canvas. 39 x 29 ½ in. Gift of Friends of Art and Hope Melamed Winter in memory of Dr. Abraham Melamed M2001.166. (See page 14.)

Robert Motherwell (American, 1915–1991). *Summertime in Italy No. 7 (in Golden Ochre),* 1961. Oil on canvas. 85 x 69 in. Gift of Friends of Art and the Dedalus Foundation, Inc. M1994.374.

Robert Motherwell (American, 1915–1991). *Two Figures with Stripe,* 1962. Acrylic on canvas. 54 x 72 in. Gift of Friends of Art and the Dedalus Foundation, Inc. M1994.375.

Ben Nicholson (English, 1894–1982). *Still Life, Crystal,* 1948. Oil and pencil on canvas. 24 x 26 ¾ in. Gift of Friends of Art (with acknowledgment to Mrs. Alfred H. Steinman Jr.) M1958.8.

Nathan Oliveira (American, b. 1928). *Untitled (Seated Figure II),* 1989. Oil on canvas. 96 x 84 in. Gift of Friends of Art M2000.19.

Philip Pearlstein (American, b. 1924). *Portrait of the Artist's Daughter (Ellen),* 1969. Oil on canvas. 60 x 48 in. Gift of Friends of Art M1970.3.

Larry Poons (American, b. 1937). *Untitled,* 1967. Acrylic on canvas. 90 ½ x 135 ¼ in. Gift of Friends of Art M1968.13.

Ad Reinhardt (American, 1913–1967). *Abstract Painting,* 1963. Oil on canvas. 60 x 60 in. Gift of Friends of Art M1967.22.

Susan Rothenberg (American, b. 1945). *Mist from the Chest,* 1983. Oil on canvas. 78 x 89 in. Gift of Friends of Art M1984.5.

David Salle (American, b. 1952). *Within Sleep,* 1985. Acrylic and oil on canvas with fabric-wrapped panel. 84 x 118 ⅛ in. Gift of Contemporary Art Society and Friends of Art M1985.73.

Paul Sarkisian (American, b. 1928). *Untitled— for John Altoon,* 1970. Acrylic on canvas. 117 ¼ x 141 in. Gift of Friends of Art with National Endowment for the Arts Matching Funds M1978.34.

Siresa Master (Spanish, 15th century). *Retable of Saint Michael and Gargano,* 1453. Tempera on wood panel. 77 x 50 in. Gift of Friends of Art M1963.33.

▸ **Francesco Solimena (Italian, 1657–1747). Madonna and Child with St. Januarius and St. Sebastian, ca. 1700**. Oil on canvas. 100 x 69 ¼ in. Gift of Friends of Art M1964.35. (See page 47.)

Frank Stella (American, b. 1936). *Chocorua III*, 1966. Fluorescent alkyd and epoxy paints on canvas. 120 x 128 in. Gift of Friends of Art M1968.12.

▶ **Matthias Stom (Dutch, ca. 1600–after 1652).** *Christ before the High Priest*, **ca. 1633**. Oil on canvas. 56 x 72 ³/₄ in. Purchase, Friends of Art, Myron and Elizabeth P. Laskin Fund, and Marjorie Tiefenthaler Bequest M2000.6. (See page 46.)

Eugene von Bruenchenhein (American, Wisconsin, 1910–1983). *Untitled*, 1957. Oil on board. 24 x 24 in. Gift of Friends of Art M1991.678.

Eugene von Bruenchenhein (American, Wisconsin, 1910–1983). *Untitled (H Bomb)*, 1954. Oil on paperboard. 21 x 26 in. Gift of Friends of Art M1991.680.

Eugene von Bruenchenhein (American, Wisconsin, 1910–1983). *Untitled (Stone and Steel/A Vast Construction/Rainbow Complex)*, 1978. Oil on cardboard. 39 x 39 in. Gift of Friends of Art M1991.679.

Tom Wesselmann (American, 1931–2004). *Still Life #51*, 1964. Formica, commercially printed paper, plastic, and acrylic on canvas. 108 x 96 x 16 ¹/₂ in. Gift of Friends of Art M1970.10.

William T. Wiley (American, b. 1937). *Harpoon for the Dreamer II*, 1982. Pastel, charcoal, and acrylic on canvas and mixed media. Two parts, (a) 84 x 144 in. and (b) 31 ¹/₂ x 55 x 17 in. Gift of Friends of Art M1984.6a,b.

PRINTS

Andrea Andriani (Italian, active 1584–1610). *Panel from the Triumph of Caesar*, 1599. Chiaroscuro woodcut. 14 ³/₈ x 14 ⁹/₁₆ in. Gift of Friends of Art from the collection of Philip and Dorothy Pearlstein M2000.118.

Georg Baselitz (German, b. 1938). *The Horse*, 1986, plate 2 from the portfolio *Eight Etchings*, published 1987. Color drypoint and aquatint on ivory wove paper. 30 x 22 ⁷/₁₆ in. Gift of Friends of Art M1991.312.

Georg Baselitz (German, b. 1938). *The Hunter*, 1967. Etching and drypoint, printed in sepia on white wove paper. 25 ⁵/₁₆ x 19 ¹/₂ in. Gift of Friends of Art M1992.36.

Fred Berman (American, Wisconsin, b. 1926). *Column*, 1961. Etching, soft-ground, and aquatint (?) on cream wove paper. 16 ¹/₂ x 12 in. Gift of Friends of Art (Purchase award, 1962 Wisconsin Drawings and Prints Show) M1962.1131.

Nicolaes de Bruyn (Flemish, 1571–1652). *Solomon's Idolatry*, 1606. Etching. 17 ⁷/₈ x 27 ¹/₂ in. Gift of Friends of Art, from the collection of Philip and Dorothy Pearlstein M2000.129.

Canaletto (Giovanni Antonio Canal) (Italian, 1697–1768). *Al Dolo*, from the series *Vedute (Views)*, 1741–47. Etching. 11 ¹³/₁₆ x 16 ⁷/₈ in. Gift of Friends of Art, from the collection of Philip and Dorothy Pearlstein M2000.125.

▶ **Canaletto (Giovanni Antonio Canal) (Italian, 1697–1768).** *View of a Town with a Bishop's Tomb*, **from the series** *Vedute (Views)*, **1741–47**. Etching. 14 ³/₄ x 11 in. Gift of Friends of Art, from the collection of Philip and Dorothy Pearlstein M2000.126. (See page 49.)

▶ **Paul Cézanne (French, 1839–1906).** *The Bathers— Large Stone*, **1896–97**. Color lithograph. 19 ¹/₄ x 24 ⁷/₈ in. Gift of Friends of Art M2000.9. (See page 50.)

▶ **Chuck Close (American, b. 1940).** *Self-Portrait*, **1977**. Etching. 55 ³/₄ x 42 ¹/₂ in. Gift of Friends of Art with National Endowment for the Arts Matching Funds M1978.33. (See page 50.)

Honoré Daumier (French, 1808–1879). *You Can Set This One Free! He Isn't Dangerous Anymore*, 1834. Lithograph on wove paper. 10 ⁷/₈ x 14 ³/₈ in. Gift of Friends of Art, from the collection of Philip and Dorothy Pearlstein M2000.128.

Ferdinand-Victor-Eugène Delacroix (French, 1798–1863). *Lion Attacking the Body of an Arab*, 1849. Etching in sanguine ink. 9 ⁹/₁₆ x 12 ⁵/₈ in. Gift of Friends of Art, from the collection of Philip and Dorothy Pearlstein M2000.130.

Stefano Della Bella (Italian, 1610–1664; active in Paris 1639–50). *Colossus of the Apennine by Giambologna*, plate 6 of 6 from the series *Vues de la villa de Pratolino (Views of the Pratolino Villa)*, ca. 1653. Etching. 9 ¹³/₁₆ x 15 ¹/₄ in. Gift of Friends of Art, from the collection of Philip and Dorothy Pearlstein M2000.132.

Emilian School (Italian, early 16th century). *Death of Virginia*, ca. 1500–10. Engraving. 9 ³/₈ x 8 ⁵/₈ in. Gift of Friends of Art, from the collection of Philip and Dorothy Pearlstein M2000.221.

▶ **Lucian Freud (English, b. Germany, 1922).** *Head and Shoulders of Girl*, **1990**. Etching with roulette on ivory wove paper. 30 ⁵/₈ x 24 ³/₄ in. Gift of Friends of Art M1991.408. (See page 50.)

Giorgio Ghisi (Italian, 1520–82). *The Vision of Ezekiel*, 1554, published 1595. Engraving. 16 ¹/₂ x 27 ¹/₈ in. Gift of Friends of Art, from the collection of Philip and Dorothy Pearlstein M2000.135.

Hendrik Goudt (Dutch, 1585–1648). *The Mocking of Ceres, after Adam Elsheimer (1578–1610)*, 1610. Engraving. 12 ³/₄ x 9 ¹⁵/₁₆ in. Gift of Friends of Art, from the collection of Philip and Dorothy Pearlstein M2000.136.

Francisco José de Goya y Lucientes (Spanish, 1746–1828). *Fool's Folly* (or *Fool's Fantasy*), ca. 1819–23, from *Los proverbios* (*Los disparates*), published 1877. Etching and aquatint. 11 ³/₈ x 15 ³/₈ in. Gift of Friends of Art, from the collection of Philip and Dorothy Pearlstein M2000.138.

Francisco José de Goya y Lucientes (Spanish, 1746–1828). *Punctual Folly* (or *Punctual Riddle*), ca. 1819–23, from *Los proverbios* (*Los disparates*), published 1877. Etching and aquatint. 12 ¹/₈ x 17 ⁷/₁₆ in. Gift of Friends of Art, from the collection of Philip and Dorothy Pearlstein M2000.137.

Francisco José de Goya y Lucientes (Spanish, 1746–1828). *Well-Known Folly* (or *Well-Known Fantasy*), ca. 1819–23, from *Los proverbios* (*Los disparates*), published 1877. Etching and aquatint. 11 ⁷/₈ x 16 ¹⁵/₁₆ in. Gift of Friends of Art, from the collection of Philip and Dorothy Pearlstein M2000.139.

Philip Guston (American, 1913–1980). *Door*, 1980. Lithograph on white wove paper. 22 x 29 ¹¹/₁₆ in. Gift of Friends of Art M1990.29.

Komar & Melamid (Vitaly Komar and Alex Melamid) (American, b. Russia, 1943; American, b. Russia, 1945). *Sunrise at Bayonne*, 1988. Color soft-ground etching, aquatint, and spitbite with copper leaf. 32 ³/₄ x 74 ¹/₄ in. Gift of Friends of Art M1991.314.

▶ **Brice Marden (American, b. 1938).** *Cold Mountain Series, Zen Studies 1–6*, **1991**. Etching with sugar lift, aquatint on white wove paper. 6 sheets, 27 ¹/₂ x 35 ¹/₄ in. each. Gift of Friends of Art M1992.136.1–.6. (See page 51.)

Henri Matisse (French, 1869–1954). *Model at Rest*, 1922, published ca. 1925. Lithograph on thin, light gray Asian wove paper. 9 ⁹/₁₆ x 12 ¹/₄ in. Gift of Friends of Art M1990.135.

Jim Nutt (American, b. 1938). *Twixt*, from the portfolio *AGB Encore*, 1997. Etching, aquatint. 27 ⁵/₈ x 20 ³/₈ in. Gift of Friends of Art M1998.8.

▶ **Giovanni Battista Piranesi (Italian, 1720–1778).** *The Grand Piazza*, **plate 4 from the series** *Carceri (Prisons)*, **1749–60**. Etching, engraving, sulfur tint or open bite, burnishing. 23 ¹³/₁₆ x 18 ¹/₂ in. Gift of Friends of Art, from the collection of Philip and Dorothy Pearlstein M2000.142. (See page 49.)

Jackson Pollock (American, 1912–1956). *Untitled*, ca. 1944–45, from a series of seven posthumously printed plates, published 1967. Drypoint on ivory wove paper. Six sheets, 10 1/16 to 20 1/16 x 13 3/4 to 27 7/16 in. each. Gift of Friends of Art M1986.128–132.

Naomi Savage (American, 1927–2005). *Pressed Flower*, 1969. Photo intaglio (blind embossing) on cream wove paper. 10 3/4 x 9 1/2 in. Gift of Friends of Art with National Endowment for the Arts Matching Funds M1978.86.

DRAWINGS

▸ **John Bard and James Bard (American, 1815–1856; American, 1815–1897).** *The Steam Ferry "Highlander,"* **ca. 1835.** Watercolor over pencil on cream wove paper. 19 x 32 7/8 in. Gift of Bob and Jo Wagner and Friends of Art M2000.8. (See page 56.)

▸ **Romare Bearden (American, 1911–1988).** *The Street,* **1964.** Collage of various papers on cardboard. 12 7/8 x 15 3/8 in. Gift of Friends of Art and African American Art Acquisition Fund M1996.52. (See pages 20 and 52.)

▸ **Carlo Carrà (Italian, 1881–1966).** *Portrait of Marinetti,* **1914.** Ink, watercolor, gouache, and collage on paper. 21 7/8 x 15 7/8 in. Gift of Friends of Art M1982.1. (See page 52.)

James Gibbs (American, 19th century). *The Chase*, ca. 1870. Ink on paper. 30 1/16 x 49 13/16 in. Gift of Friends of Art M1974.67.

▸ **Richard Haas (American, b. 1936).** *Presentation Drawing for Design for Centre Theater Building, Milwaukee,* **1981.** Gouache on paper. 65 x 44 3/4 in. Gift of Friends of Art M1989.97. (See page 40.)

▸ **William Kentridge (South African, b. 1955).** *Drawing for the Film "Monument,"* **1990.** Charcoal and pastel on cream wove paper. 47 1/4 x 59 1/8 in. Gift of Friends of Art M1999.29. (See page 52.)

▸ **Michael Lenk (American, Wisconsin, 1890–1982).** *The Fifth Day of Creation,* **ca. 1965.** Watercolor over pencil on heavy white wove paper. 22 1/8 x 30 1/4 in. Gift of Friends of Art M1996.381. (See page 58.)

▸ **Sol LeWitt (American, 1928–2007).** *Wall Drawing #88 (Wall Drawing for the Milwaukee Art Center),* **1971.** Graphite on wallboard. Dimensions variable. Gift of Friends of Art M2006.1. (See page 67.)

Robert Motherwell (American, 1915–1991). *An Elegy to the Spanish Republic*, 1959. Black ink on paper. 21 1/2 x 27 3/4 in. Gift of Friends of Art and the Dedalus Foundation, Inc. M1994.373.

Cornelia Parker (English, b. 1956). *Poison and Antidote Drawings*, 1997. Snake venom mixed with ink and antivenom mixed with correction fluid on paper. Two sheets, 24 x 24 in. each. Gift of Friends of Art M2000.7.1,.2.

Philip Pearlstein (American, b. 1924). *Model on Rug with Bench and Mirror*, 1974. Watercolor on paper. 30 3/8 x 22 1/4 in. Gift of Friends of Art M1996.399.

▸ **Martín Ramírez (American, b. Mexico, 1885–1960).** *Untitled (Landscape with Train, Church, and Animals),* **ca. 1950s.** Pencil, colored pencil, poster paint, and white paper collage on brown kraft paper. 36 x 130 1/2 in. Gift of Friends of Art and Jim Nutt and Gladys Nilsson M1997.113. (See pages 6 and 57.)

▸ **Joseph Stella (American, 1877–1946).** *The Quencher (Night Fires),* **ca. 1919.** Pastel on paper. 22 1/2 x 29 in. Gift of Friends of Art M1978.32. (See page 53.)

PHOTOGRAPHS

▸ **Berenice Abbott (American, 1898–1991).** *Blossom Restaurant,* **1935.** Gelatin silver print. 7 5/16 x 9 5/8 in. Gift of Friends of Art with National Endowment for the Arts Matching Funds M1978.57. (See page 61.)

Berenice Abbott (American, 1898–1991). *New York at Night*, 1934. Gelatin silver print, printed later. 13 11/16 x 10 5/8 in. Gift of Friends of Art with National Endowment for the Arts Matching Funds M1978.66.

Michael Abramson (American, b. 1948). *New Jazz Showcase Lounge*, 1975. Gelatin silver print. 8 3/16 x 12 5/16 in. Gift of Friends of Art with National Endowment for the Arts Matching Funds M1978.99.

Michael Abramson (American, b. 1948). *Patio Lounge*, 1975. Gelatin silver print. 8 1/16 x 12 1/4 in. Gift of Friends of Art with National Endowment for the Arts Matching Funds M1978.100.

Michael Abramson (American, b. 1948). *Perv's House*, 1976. Gelatin silver print. 8 1/8 x 12 3/16 in. Gift of Friends of Art with National Endowment for the Arts Matching Funds M1978.101.

Ansel Adams (American, 1902–1984). *Calaveras, North Grove*, ca. 1930. Gelatin silver print. 14 15/16 x 10 13/16 in. Gift of Friends of Art with National Endowment for the Arts Matching Funds M1978.65.

▸ **Ansel Adams (American, 1902–1984).** *Moonrise, Hernandez, New Mexico,* **1941.** Gelatin silver print, printed 1977. 15 1/2 x 19 7/8 in. Gift of Friends of Art with National Endowment for the Arts Matching Funds M1977.10. (See page 62.)

Ruth Bernhard (American, 1905–2006). *Buddha Doll*, 1938. Gelatin silver print, printed later. 7 1/4 x 7 7/16 in. Gift of Friends of Art with National Endowment for the Arts Matching Funds M1978.84.

Ruth Bernhard (American, 1905–2006). *Classic Nude (after 1947 photograph)*, 1947. Gelatin silver print, printed ca. 1976. 10 x 7 5/8 in. Gift of Friends of Art with National Endowment for the Arts Matching Funds M1978.53.

Ruth Bernhard (American, 1905–2006). *Laundry Line*, 1940s. Gelatin silver print. 10 x 10 7/16 in. Gift of Friends of Art with National Endowment for the Arts Matching Funds M1978.85.

▸ **Harry Callahan (American, 1912–1999).** *Aix-en-Provence,* **ca. 1958.** Gelatin silver print, printed 1970s. 7 x 5 7/16 in. Gift of Friends of Art with National Endowment for the Arts Matching Funds M1978.67. (See page 19.)

Harry Callahan (American, 1912–1999). *New York*, ca. 1969–70. Gelatin silver print. 9 15/16 x 9 3/8 in. Gift of Friends of Art with National Endowment for the Arts Matching Funds M1978.83.

Paul Caponigro (American, b. 1932). *Stonehenge*, 1967. Gelatin silver print, printed 1977. 12 5/8 x 12 1/16 in. Gift of Friends of Art with National Endowment for the Arts Matching Funds M1978.59.

Judy Dater (American, b. 1941). *Imogen and Twinka at Yosemite*, 1974. Gelatin silver print. 9 5/8 x 7 9/16 in. Gift of Friends of Art with National Endowment for the Arts Matching Funds M1978.62.

Judy Dater (American, b. 1941). *Twinka*, 1970. Gelatin silver print. 9 1/2 x 7 9/16 in. Gift of Friends of Art with National Endowment for the Arts Matching Funds M1978.74.

▸ **Walker Evans (American, 1903–1975).** *Couple at Coney Island,* **1928.** Gelatin silver print. 10 1/8 x 8 in. Gift of Friends of Art M2006.5. (See page 60.)

Lee Friedlander (American, b. 1934). *Albuquerque*, 1972. Gelatin silver print, printed 1978. 7 1/2 x 11 1/8 in. Gift of Friends of Art with National Endowment for the Arts Matching Funds M1978.58.

▶ **Alexander Gardner (American, 1821–1882).**
Dead Confederate Soldier at Devil's Den,
Gettysburg, July 6, 1863, plate 41 from Gardner's
Photographic Sketchbook of the Civil War, 1863.
Albumen silver print from glass negative.
6 ⁷/₁₆ x 8 ³/₈ in. Gift of Friends of Art M1989.102.
(See page 59.)

Emmet Gowin (American, b. 1941). *Elijah, Nancy,*
Dwayne, Danville, 1969. Gelatin silver print.
7 ⁷/₈ x 9 ¹³/₁₆ in. Gift of Friends of Art with National
Endowment for the Arts Matching Funds
M1978.64.

Emmet Gowin (American, b. 1941). *Ireland,* 1972.
Gelatin silver print, printed 1976. 7 ¹⁵/₁₆ x 9 ¹⁵/₁₆ in.
Gift of Friends of Art with National Endowment
for the Arts Matching Funds M1978.54.

Emmet Gowin (American, b. 1941). *Ruth, Danville,*
Virginia, 1968. Gelatin silver print. 5 ⁵/₈ x 5 ¹¹/₁₆ in.
Gift of Friends of Art with National Endowment
for the Arts Matching Funds M1978.103.

Lotte Jacobi (American, 1896–1990). *Self-Portrait,*
ca. 1935. Gelatin silver print, printed later. 9 ³/₁₆ x
6 ¹¹/₁₆ in. Gift of Friends of Art M1989.104.

André Kertész (American, b. Hungary, 1894–1985).
Carrefour Blois, 1930. Gelatin silver print, printed
1978. 7 ¼ x 9 ³/₄ in. Gift of Friends of Art with
National Endowment for the Arts Matching Funds
M1978.56.

André Kertész (American, b. Hungary, 1894–1985).
Chez Mondrian, 1926. Gelatin silver print, printed
1978. 9 ³/₄ x 7 ¼ in. Gift of Friends of Art with
National Endowment for the Arts Matching Funds
M1978.96.

André Kertész (American, b. Hungary, 1894–1985).
Rainy Day, Tokyo, 1968. Gelatin silver print,
printed 1978. 9 ³/₄ x 5 ¹¹/₁₆ in. Gift of Friends of
Art with National Endowment for the Arts
Matching Funds M1978.98.

▶ **André Kertész (American, b. Hungary, 1894–**
1985). *Satiric Dancer,* 1926. Gelatin silver print,
printed 1978. 9 ³/₄ x 7 ³/₄ in. Gift of Friends of Art
with National Endowment for the Arts Matching
Funds M1978.97. (See page 62.)

Robert E. Lewis (American, Wisconsin, b. 1940).
Eyewitness, 1972. Gelatin silver print, printed 1978.
6 ¼ x 9 in. Gift of Friends of Art with National
Endowment for the Arts Matching Funds M1978.55.

Robert E. Lewis (American, Wisconsin, b. 1940).
Maxfactor Eyes, 1969. Gelatin silver print, printed
1978. 5 ⁷/₈ x 4 in. Gift of Friends of Art with
National Endowment for the Arts Matching Funds
M1978.93.

Danny Lyon (American, b. 1942). *Mary, the*
Queen of the Arbolito, Santa Marta, Colombia,
1972. Gelatin silver print. 9 x 13 ⁷/₁₆ in. Gift of
Friends of Art with National Endowment for the
Arts Matching Funds M1978.73.

Duane Michals (American, b. 1932). *Gerard Mistral,*
from the series *Homage to C. P. Cavafy,* 1978.
Gelatin silver print. 4 ¹¹/₁₆ x 6 ¹/₁₆ in. Gift of Friends
of Art M1989.105.

Barbara Morgan (American, 1900–1992).
Emanation, 1940. Gelatin silver print, printed
1978. 13 ⁵/₁₆ x 10 ¼ in. Gift of Friends of Art with
National Endowment for the Arts Matching
Funds M1978.80.

Barbara Morgan (American, 1900–1992).
Martha Graham—Lamentation, 1935. Gelatin
silver print, printed 1978. 9 ³/₄ x 12 ⁷/₈ in. Gift of
Friends of Art with National Endowment for the
Arts Matching Funds M1978.78.

Barbara Morgan (American, 1900–1992). *Spring,*
Madison Square, 1938. Gelatin silver print
(photomontage), printed 1978. 10 ¼ x 12 ⁹/₁₆ in.
Gift of Friends of Art with National Endowment
for the Arts Matching Funds M1978.79.

Barbara Morgan (American, 1900–1992). *Valerie*
Bettis—Desperate Heart, 1944. Gelatin silver
print, printed later. 13 ⁵/₁₆ x 10 ⁷/₁₆ in. Gift of
Friends of Art with National Endowment for the
Arts Matching Funds M1978.52.

James B. Murdoch (Murdoch Photographing
Company, Milwaukee) (American, 1898–1972).
Industrial Scene, Menomonee River Valley,
Milwaukee, 1920s. Two gelatin silver prints
(panorama). 6 ³/₄ x 17 ½ in. overall. Gift of Friends
of Art M1989.413.1–.2.

James B. Murdoch (Murdoch Photographing
Company, Milwaukee) (American, 1898–1972).
View of Bathing Beach and Club House, Milwaukee
Yacht Club, 1929. Two gelatin silver prints
(panorama). 7 ⁵/₈ x 18 ³/₈ in. overall. Gift of Friends
of Art M1989.412.1–.2.

James B. Murdoch (Murdoch Photographing
Company, Milwaukee) (American, 1898–1972).
View of Milwaukee Shoreline and Lincoln Memorial
Drive from Cudahy Apartments, 1929. Two gelatin
silver prints (panorama). 7 ⁹/₁₆ x 18 ½ in. overall.
Gift of Friends of Art M1989.411.1–.2.

James B. Murdoch (Murdoch Photographing
Company, Milwaukee) (American, 1898–1972).
View of North Avenue Reservoir, Milwaukee,
1929. Three gelatin silver prints (panorama).
7 ³/₈ x 28 in. overall. Gift of Friends of Art
M1989.414.1–.3.

James B. Murdoch (Murdoch Photographing
Company, Milwaukee) (American, 1898–1972).
View West of Wisconsin Avenue, Milwaukee,
from Pabst Building, 1920s. Gelatin silver print.
7 ½ x 9 ½ in. Gift of Friends of Art M1989.410.

James B. Murdoch (Murdoch Photographing
Company, Milwaukee) (American, 1898–1972).
Views of Milwaukee from Telephone Company
Building, 1920s. Four gelatin silver prints
(panorama). 7 ¹/₁₆ x 36 in. overall. Gift of Friends
of Art M1989.409.1–.4.

Marion Palfi (American, b. 1917). *Waiting Room,*
Miami, Florida, 1947. Gelatin silver print, printed
1960s. 13 ¹¹/₁₆ x 10 ½ in. Gift of Friends of Art
with National Endowment for the Arts Matching
Funds M1978.72.

Olivia Parker (American, b. 1941). *Statue Seen*
by a Man and Observed by a Pigeon, 1984.
Toned gelatin silver print. 13 ⁵/₈ x 10 ¹⁵/₁₆ in. Gift of
Friends of Art M1989.108.

▶ **Cindy Sherman (American, b. 1954).** *Untitled,*
1985. Chromogenic print. 47 ⁵/₈ x 64 ½ in. Gift of
Friends of Art M1985.60. (See page 63.)

Aaron Siskind (American, 1903–1991). *Chicago*
202, 1953. Gelatin silver print, printed later.
13 ³/₁₆ x 10 ¼ in. Gift of Friends of Art with National
Endowment for the Arts Matching Funds
M1978.60.

Aaron Siskind (American, 1903–1991).
Guadalajara, Mexico, 3, 1961. Gelatin silver print,
printed later. 10 ⁵/₈ x 13 ³/₈ in. Gift of Friends of Art
with National Endowment for the Arts Matching
Funds M1978.102.

Ralph Steiner (American, 1899–1986).
Ten Photographs from the Twenties and Thirties
and One from the Seventies, 1978. Gelatin silver
prints. 10 prints and 1 portfolio box cover, 12 ³/₄ to
18 x 10 ¹⁵/₁₆ to 17 in. each. Gift of Friends of Art
M1980.10a–k.

Alfred Stieglitz (American, 1864–1946). *Hands*
of Georgia O'Keeffe, 1917. Platinum print. 9 ⁷/₈ x
7 ⁷/₈ in. Gift of Earl A. and Catherine V. Krueger,
Jane Bradley Pettit Foundation, and Friends of Art
M1997.50.

▶ **Alfred Stieglitz (American, 1864–1946).**
Portrait of Georgia O'Keeffe, **1918.** Gelatin silver
print. 9 ⁵/₈ x 7 ⁵/₈ in. Gift of Earl A. and Catherine
V. Krueger, Jane Bradley Pettit Foundation, and
Friends of Art M1997.51. (See page 62.)

Alfred Stieglitz (American, 1864–1946). *Portrait*
of Georgia O'Keeffe, 1920. Platinum-palladium
print. 9 ⁷/₈ x 7 ⁷/₈ in. Gift of Earl A. and Catherine
V. Krueger, Jane Bradley Pettit Foundation, and
Friends of Art M1997.52.

Alfred Stieglitz (American, 1864–1946). *Spring Showers*, plate XVI from *Camera Work*, no. 36, ca. 1900. Photogravure, printed ca. 1911. 9 ¹/₁₆ x 3 ¹¹/₁₆ in. Gift of Friends of Art M1981.25.

Alfred Stieglitz (American, 1864–1946). *The Steerage*, plate IX from *Camera Work*, no. 36, 1907. Photogravure, printed ca. 1911. 7 ¹³/₁₆ x 6 ¼ in. Gift of Friends of Art M1981.26.

Alfred Stieglitz (American, 1864–1946). *The Terminal*, plate XV from *Camera Work*, no. 36, 1892. Photogravure, printed ca. 1911. 11 ¹/₁₆ x 7 ⁷/₈ in. Gift of Friends of Art M1981.24.

▶ **Paul Strand (American, 1890–1976).** *House of a Fisherman, Vera Cruz, Mexico***, 1934**. Gelatin silver print. 4 ⁵/₁₆ x 6 in. Gift of Friends of Art M1980.24. (See page 61.)

Edmund Teske (American, 1911–1996). *Full-Length Portrait, Frank Lloyd Wright, Taliesin, Spring Green, Wisconsin*, 1936. Gelatin silver print, printed 1978. 12 x 10 ¼ in. Gift of Friends of Art with National Endowment for the Arts Matching Funds M1978.89.

Edmund Teske (American, 1911–1996). *Male Nude, Back View, Topanga Canyon, California*, 1954. Gelatin silver print, printed 1978. 10 ⁵/₁₆ x 13 ⁷/₈ in. Gift of Friends of Art with National Endowment for the Arts Matching Funds M1978.87.

Edmund Teske (American, 1911–1996). *Semi-Nude Woman with Mandrake Root-Composite with Growth of Reeds (Mrs. Tony Smith)*, 1944 and 1947. Gelatin silver print, printed 1978. Gift of Friends of Art with National Endowment for the Arts Matching Funds M1978.88.

Edmund Teske (American, 1911–1996). *The Taliesin North of Frank Lloyd Wright, Spring Green, Wisconsin*, 1938. Gelatin silver print, printed 1978. 9 ¹/₂ x 13 ¹/₂ in. Gift of Friends of Art with National Endowment for the Arts Matching Funds M1978.90.

George Tice (American, b. 1938). *Porch, Monhegan Island, Maine*, 1971. Gelatin silver print. 9 ¹/₂ x 6 ³/₈ in. Gift of Friends of Art with National Endowment for the Arts Matching Funds M1978.76.

George Tice (American, b. 1938). *Shaker Interior, Sabbathday Lake, Maine*, 1971. Gelatin silver print. 6 ¹/₂ x 9 ¹/₂ in. Gift of Friends of Art with National Endowment for the Arts Matching Funds M1978.77.

Wolfgang Tillmans (German, b. 1968). *Erasure*, 1988. Chromogenic print. 10 ¹/₈ x 15 in. Gift of Friends of Art M1999.55.

Wolfgang Tillmans (German, b. 1968). *Hong Kong Airport*, 1988. Chromogenic print. 10 ⁷/₈ x 16 in. Gift of Friends of Art M1999.54.

Wolfgang Tillmans (German, b. 1968). *Phillip Light*, 1997. Chromogenic print. 24 x 16 ³/₁₆ in. Gift of Friends of Art M1999.53.

Arthur Tress (American, b. 1940). *Girl Gathering Goldfish, Château Breteuil, France*, 1974. Gelatin silver print. 10 ³/₄ x 10 ³/₄ in. Gift of Friends of Art with National Endowment for the Arts Matching Funds M1978.95.

Arthur Tress (American, b. 1940). *Shadow #2*, 1974. Gelatin silver print. 7 ⁷/₁₆ x 7 ¹/₂ in. Gift of Friends of Art with National Endowment for the Arts Matching Funds M1978.94.

Jerry N. Uelsmann (American, b. 1934). *Simultaneous Intimations*, 1965. Gelatin silver print. 13 ¹¹/₁₆ x 10 ⁵/₈ in. Gift of Friends of Art with National Endowment for the Arts Matching Funds M1978.81.

Jerry N. Uelsmann (American, b. 1934). *Untitled*, 1969. Gelatin silver print. 9 ³/₄ x 12 ³/₄ in. Gift of Friends of Art with National Endowment for the Arts Matching Funds M1978.63.

Jerry N. Uelsmann (American, b. 1934). *Untitled*, 1976. Gelatin silver print. 13 ³/₁₆ x 9 ¹/₂ in. Gift of Friends of Art with National Endowment for the Arts Matching Funds M1978.82.

▶ **Eugene von Bruenchenhein (American, Wisconsin, 1910–1983).** *Portrait of the Artist's Wife, Marie (Seated)***, ca. 1940s**. Gelatin silver print. 9 ⁵/₁₆ x 6 ¼ in. Gift of Friends of Art M1991.612. (See page 57.)

Jack Welpott (American, b. 1923). *Farm Twins*, 1958. Gelatin silver print, printed later. 8 ¹⁵/₁₆ x 11 ⁷/₈ in. Gift of Friends of Art with National Endowment for the Arts Matching Funds M1978.92.

Jack Welpott (American, b. 1923). *Sabine, Arles*, 1973. Gelatin silver print. 9 ⁵/₈ x 7 ¹/₂ in. Gift of Friends of Art with National Endowment for the Arts Matching Funds M1978.75.

Jane B. Wenger (American, b. 1944). *Untitled*, 1976. Gelatin silver print. 2 ⁷/₈ x 4 ⁵/₈ in. Gift of Friends of Art with National Endowment for the Arts Matching Funds M1978.70.

Jane B. Wenger (American, b. 1944). *Untitled*, 1976. Gelatin silver print. 3 ¹³/₁₆ x 3 in. Gift of Friends of Art with National Endowment for the Arts Matching Funds M1978.71.

Jane B. Wenger (American, b. 1944). *Untitled*, 1977. Gelatin silver print. 13 ⁷/₈ x 17 ³/₄ in. Gift of Friends of Art with National Endowment for the Arts Matching Funds M1978.91.

Garry Winogrand (American, 1928–1984). *New York*, 1968. Gelatin silver print, printed later. 9 x 13 ⁵/₁₆ in. Gift of Friends of Art with National Endowment for the Arts Matching Funds M1978.68.

▶ **Garry Winogrand (American, 1928–1984).** *San Marcos, Texas***, 1964**. Gelatin silver print. 8 ¹⁵/₁₆ x 13 ³/₈ in. Gift of Friends of Art with National Endowment for the Arts Matching Funds M1978.69. (See page 63.)

Dina Woelffer (American, b. ca. 1925). *Hands*, 1967. Gelatin silver print. 18 ⁷/₁₆ x 15 ¹/₂ in. Gift of Friends of Art with National Endowment for the Arts Matching Funds M1978.104.

SCULPTURE

Magdalena Abakanowicz (Polish, b. 1930). *Two Figures on Beam*, 1992. Burlap, resin, wood. 84 ¼ x 104 ³/₄ x 22 ¹/₂ in. Gift in honor of Russell Bowman (Director, 1985–2002) by Contemporary Art Society, Donald and Donna Baumgartner, Friends of Art, Marianne and Sheldon B. Lubar, Harry V. and Betty Quadracci, Reiman Foundation, Sue and Bud Selig, Anthony and Andrea Bryant, Fund of the Greater Milwaukee Foundation, Phyllis and William Huffman, Jane and George Kaiser, Phoebe R. and John D. Lewis Foundation, Marcus Corporation Foundation, James and Joanne Murphy, Gilbert and J. Dorothy Palay Family Foundation, Anthony Petullo Foundation, Suzanne and Richard Pieper Family Foundation, Justin and Holly Segel, Reva and Phil Shovers, Hope and Elmer Winter, African American Art Alliance, Nancy and Terry Anderson, Karen and William Boyd, Marilyn and Orren Bradley, Collectors' Corner, the Docents of the Milwaukee Art Museum, Jean and Ted Friedlander, Judy Gordon and Martin Siegel, George and Angela Jacobi, Susan and Lee Jennings, David and Cynthia Kahler, Herbert H. Kohl Charities, Inc., Mary Ann and Charles P. LaBahn, Arthur and Nancy Laskin, P. Michael Mahoney, Donna and Tony Meyer, Joyce and Nick Pabst, Jill and Jack Pelisek, Anne H. and Frederick Vogel III, David and Sibyl Wescoe, Kathy and David Yuille, and Friends of Art M2002.59.

Stephen Antonakos (American, b. Greece, 1926). *White Hanging Neon*, 1966. Neon-lighted construction. Gift of Friends of Art in memory of Harry Lynde Bradley M1967.50.

Robert Arneson (American, 1930–1992). *Desolatus*, 1984. Polychrome. 27 in. (head); 50 ¹/₂ x 29 in. (pedestal). Purchase, Friends of Art M1984.78.

Larry Bell (American, b. 1939). *Untitled*, 1972. Vacuum-plated glass. 71 7/8 x 71 3/4 x 3/8 in. Gift of Friends of Art M1973.90.

Larry Bell (American, b. 1939). *Untitled Box*, 1969. Vacuum-plated glass with chrome-plated metal frame. 20 3/16 in. cube. Gift of Mr. and Mrs. Eugene M. Schwartz, New York, and Friends of Art M1970.5.

▸ **Alexander Calder (American, 1898–1976).** *Just a Sumac to You, Dear*, **ca. 1965**. Painted sheet metal, steel wire, rod. 39 x 76 in. Gift of Friends of Art M1965.15. (See page 64.)

▸ **James Castle (American, 1900–1977).** *Untitled (Construction [Doll])*, **n.d.** Assemblage of found paper with soot and string. 11 3/4 x 5 1/2 in. Gift in honor of Russell Bowman (Director, 1985–2002) by Contemporary Art Society, Donald and Donna Baumgartner, and Friends of Art M2002.157. (See page 13.)

Clodion (Claude Michel) (French, 1783–1814). *Pair of Bacchic Groups with Nymph, Satyr, and Infant*, ca. 1775. Terra-cotta. 19 1/2 in. ea. Purchase, Friends of Art and the Leon and Marion Kaumheimer Bequest M1977.12a,b.

Ulysses Davis (American, 1913–1990). *Hubert Humphrey*, ca. 1970. Carved wood with paint. 16 x 7 x 4 in. Gift of Friends of Art M1997.65.

Burgoyne Diller (American, 1905–1965). *Construction*, 1948–60. Painted wood. 25 1/2 x 25 1/2 x 2 3/4 in. Gift of Friends of Art M1979.46.

▸ **Duane Hanson (American, 1925–1996).** *Janitor*, **1973.** Polyester, fiberglass, mixed media (fiberglass cast from human figure with surface polyester and talcum mix, polychromed in oil with clothing and mixed media). 65 1/2 x 28 x 22 in. Gift of Friends of Art M1973.91. (See front cover and page 68.)

▸ **Eva Hesse (American, b. Germany, 1936–1970).** *Right After*, **1969.** Fiberglass. Dimensions vary on installation. Gift of Friends of Art M1970.27. (See page 65.)

Robert Irwin (American, b. 1928). *Untitled*, 1969. Acrylic paint on cast acrylic. Dia. 46 in. Gift of Friends of Art M1983.205.

Joseph Kosuth (American, b. 1945). *One and Three Hammers*, 1965. Hammer, photographic print of hammer, photostat of hammer definition. 24 x 53 3/8 in. Gift of Friends of Art M1984.7a–m.

Stanley Landsman (American, b. 1930). *The Magic Theatre (Walk-in Infinity Chamber)*, 1968. Wood, glass, light bulbs, electric circuitry. Gift of the artist and Friends of Art M1974.117

Attributed to Ralph McCarry (American, b. ca. 1900). *Untitled (Indian)*, ca. 1950. Carved wood with paint. 70 x 21 x 7 in. Gift of Friends of Art M1991.397.

▸ **Henry Moore (English, 1898–1986).** *Working Model for Draped Seated Woman: Figure on Steps*, **1956.** Hollow bronze cast, bronze color finish. 15 in. above base. Gift of Friends of Art M1959.399. (See page 64.)

▸ **Robert Morris (American, b. 1931).** *Untitled*, **1970.** Industrial felt. Dimensions vary on installation. Gift of Friends of Art M1970.28. (See page 65.)

Reuben Nakian (American, 1897–1986). *Minerva*, from the series *Judgment of Paris*, 1985 (after plaster model, 1965–66). Bronze. 96 x 75 1/2 x 53 in. Gift of the Milwaukee Foundation, Virginia and Robert V. Krikorian, and Friends of Art M1985.20.

Walter Nottingham (American, b. 1930). *Celibacy*, 1968. Wool. 72 x 30 x 12 in. Gift of Friends of Art M1996.423.

▸ **Claes Oldenburg (American, b. Sweden, 1929).** *Trowel—Scale A 3/3*, **1970.** Aluminum on steel base filled with dirt. 104 x 26 x 24 in. Gift of Friends of Art M1973.80. (See pages 5 and 66.)

▸ **José Benito Ortega (American, 1858–1941).** *Crucifixion*, **ca. 1885.** Carved and painted wood. 38 1/4 x 27 3/4 x 6 3/4 in. Gift of Friends of Art M1997.103. (See page 56.)

▸ **Nam June Paik (Korean, 1932–2006).** *Ruin*, **2001.** Antique television cabinets, color television screens. 164 x 228 x 26 in. Gift of Friends of Art in celebration of their 50th anniversary, and by Allen and Vicki Samson in honor of Russell Bowman and Christopher Goldsmith, by exchange M2007.38. (See page 72.)

▸ **Cornelia Parker (English, b. 1956).** *Edge of England*, **1999.** Chalk, wire, wire mesh. Dimensions vary on installation. Gift of Friends of Art M2000.89. (See page 72.)

John Van Saun (American, b. 1939). *Denver*, 1967. Electric light construction. Gift of Friends of Art in memory of Harry Lynde Bradley M1967.49.

▸ **George Segal (American, 1924–2000).** *The Store Window*, **1969.** Mixed-media construction with plaster, wood, Plexiglas, aluminum, venetian blinds, fluorescent light. 96 x 103 x 39 3/4 in. Gift of Friends of Art M1970.9. (See page 66.)

Richard Stankiewicz (American, 1922–1983). *Untitled 1958–16*, 1958. Welded steel. 30 x 16 x 12 in. Gift of John Lloyd Taylor Memorial Fund and Friends of Art M1986.152.

Thomas Tadlock (American, b. 1941). *Light Machine*, 1966. Aluminum, Plexiglas. 24 1/2 x 25 1/2 x 12 in. Gift of Friends of Art in memory of Harry Lynde Bradley M1967.48.

DeWain Valentine (American, b. 1936). *Concave Circle*, 1970. Cast polyester resin. 70 1/2 x dia. 72 1/2 in. Gift of Friends of Art M1970.4

▸ **Eugene von Bruenchenhein (American, Wisconsin, 1910–1983).** *Crown*, **late 1960s.** Painted clay, mixed media. 5 x 7 x 8 in. Gift of Friends of Art M1991.681. (See page 57.)

Eugene von Bruenchenhein (American, Wisconsin, 1910–1983). *Face (Misda)*, late 1960s. Painted concrete. 41 x 24 x 4 in. Gift of Friends of Art M1991.682.

Eugene von Bruenchenhein (American, Wisconsin, 1910–1983). *Flower with Stem*, 1940s–1960s. Painted clay. 6 1/2 x 4 x 4 1/2 in. Gift of Friends of Art M1991.684.

Eugene von Bruenchenhein (American, Wisconsin, 1910–1983). *Vessel*, 1961. Painted clay. 27 x dia. 9 1/2 in. Gift of Friends of Art M1991.683.

Clarence and Grace Woolsey (American, 1929–1987; American, d. 1988). *Bottlecap Figure*, 1970. Bottle caps, nails, wood. 43 x 20 x 12 in. Gift of Friends of Art and Ruth and Robert Vogele M1998.95.

Claire Zeisler (American, 1903–1991). *High Rise*, 1983–84. Hemp, synthetic fiber. 152 x 144 x 60 in. Gift of Friends of Art M1991.625.

Unknown artist (African, Teke). *Standing Figure (Butti)*, n.d. Wood. H. 13 1/4 in. Gift of Friends of Art in honor of Christopher Goldsmith M2002.110.

Unknown artist (American). *Bell's Bar Weightlifter*, 1950s. Metal, wood, paint. 33 x 35 x 17 in. Gift of Friends of Art M1997.66.

DECORATIVE ART

Candlestick, mid-17th century. Dutch. Brass. 6 1/2 x dia. 5 in. Gift of Friends of Art M1969.18.

Tankard, 1695–1705. Cornelius Kierstede (American, 1674–1757). Silver. 6 5/8 x dia. 5 in. Gift of Friends of Art M1977.11.

Chandelier, 1710–30. G. H. van Hengel Jr. (Dutch, n.d.). Brass, cast iron. 42 1/2 x 36 3/4 in. Gift of Friends of Art M1974.232.

Looking Glass, 1750–70. English. Mahogany, white pine, spruce, mirrored glass, gilding. 47 1/2 x 22 3/4 in. Gift of Friends of Art M1969.11.

Chair, 1755–85. New York. Santo Domingo mahogany, hard pine, sylvestris pine. 38 5/8 x 24 1/4 x 22 3/4 in. Gift of Friends of Art M1967.28a.

▸ *High Chest of Drawers*, **1755–75**. Boston or Salem, Massachusetts. Mahogany, white pine, brass hardware. 85 1/2 x 40 1/2 x 20 3/4 in. Gift of Friends of Art M1969.13. (See page 54.)

Pole Screen, ca. 1760–70. English. Mahogany, tapestry-weave panel. 56 x 20 1/2 in. Gift of Friends of Art M1969.15.

Side Chair, 1765–75. Boston or Salem, Massachusetts. Mahogany veneer, maple, birch, modern silk damask upholstery. 38 x 22 7/8 x 21 1/2 in. Gift of Friends of Art M1976.37.

▸ *Coffeepot*, **1765–90**. Thomas Shields (American, active ca. 1765–1794). Silver, fruitwood. 13 1/2 x 8 7/8 x 5 1/4 in. Gift of Friends of Art M1981.5. (See page 54 and back cover.)

Card Table, 1770–90. Attributed to John Townsend (American, 1732–1809). Mahogany, hickory, eastern white pine, cherry. 27 15/16 x 33 7/8 x 33 1/4 in. Gift of Friends of Art M1969.12.

Side Chair, ca. 1770–90. Boston. Stained mahogany. 38 7/8 x 19 5/8 x 15 1/8 in. Gift of Friends of Art M1969.14.

Chest of Drawers, 1790–1800. Probably eastern Massachusetts. White pine, brass hardware. 33 x 41 3/4 x 22 3/4 in. Gift of Friends of Art M1973.151.

Needlework Sampler, 1799. Sally (Sarah) Johnson (American, 1787–1868). Silk on linen. 19 x 27 in. Gift of Collectors' Corner and Friends of Art M1991.403.

Box, 1830–50. American, Shaker. Wood. 6 1/2 x dia. 11 in. Gift of Friends of Art SM1966.43.

Cupboard, 1830–50. American, Shaker. Pine, maple. 90 3/4 x 39 x 20 5/8 in. Gift of Friends of Art SM1966.36.

Shaker Sewing Table, 1830–50. Sabbath Day Lake (Shaker), Maine. Maple. 25 1/2 x 17 x 17 in. Gift of Friends of Art SM1966.34.

Stove, 1830–50. American, Shaker. Iron. Gift of Friends of Art SM1966.37.

Oval Box, ca. 1850. American, Shaker. Wood. 3 x 7 1/2 x 5 in. Gift of Friends of Art SM1966.44c.

▸ *Sewing Desk*, **ca. 1850**. Canterbury Shaker Village, New Hampshire. Maple. 38 1/2 x 27 3/8 x 23 5/8 in. Gift of Friends of Art, by exchange M1969.30. (See page 55.)

▸ *Crazy Quilt*, **1883**. Margaret (Maggie) Beattie (Janesville, Wisconsin, n.d.). Silk floss, silk chenille, metallic yarn, and oil paint on silk and silk velvet. 76 x 64 1/2 in. Purchase, Marion Wolfe, Mrs. Helen L. Pfeifer, and Friends of Art M1997.58. (See page 55.)

Workstand, 1897. Peter Glass (American, Wisconsin, b. Germany, 1824–1901). Mahogany, maple, cedar, walnut veneer, inlays of other woods. 29 x 20 1/2 x 20 1/2 in. Gift of Friends of Art M1997.168.

Rocking Chair, ca. 1900. American, New Lebanon Shaker Community. Maple, woven seat. 22 1/2 x 13 1/4 x 16 5/8 in. Gift of Friends of Art SM1966.47.

Side Chair, ca. 1900. Eugène Gaillard (French, 1862–1933). Produced by Salon de L'Art Nouveau. Walnut, embossed leather. 35 7/8 x 18 1/8 x 23 in. Gift of Friends of Art and the Ludner family in honor of Erna and Richard Flagg M1991.186.

Covered Pitcher, designed 1903. Richard Riemerschmid (German, 1868–1957). Produced by Reinhold Merkelbach. Salt-glazed stoneware and pewter. 10 5/6 x dia. 7 1/2 in. Gift of Friends of Art M1991.409.

Man's Wrapper (Kente), early/mid-20th century. African, Togo or Ghana. Cellulosic fiber. 115 x 63 in. Gift of Friends of Art M2000.176.

"Ruba Rombic" Vase, designed and patented 1928. Reuben Haley (American, 1872–1933). Produced by Consolidated Lamp and Glass Co. Glass. 9 1/8 x 8 x 7 1/2 in. Gift of Friends of Art M1998.92.

▸ *Reclining Chair*, **designed 1932**. Marcel Breuer (German, b. Hungary, 1902–1981). Produced by Embru Werke. Aluminum, painted wood. 29 1/4 x 23 1/2 x 41 in. Gift of Friends of Art M1992.241. (See page 18.)

Ritual Vessel, mid-20th century. African, Yoruba. Terra-cotta. 18 x 14 in. Gift of Friends of Art M2000.177a,b.

"Antony" Chair, ca. 1950. Jean Prouvé (French, 1901–1984). Produced by Les Ateliers Jean Prouvé. Plywood, painted steel. 33 3/4 x 20 x 26 in. Gift of Friends of Art M2000.10.

Bowl, 1964. Ramun Wengren (American, Wisconsin, b. 1939). Stoneware. 8 3/8 x 17 in. Gift of Friends of Art M1964.148.

Bottle, 1965. Verne Funke (American, Wisconsin, b. 1932). Earthenware. 9 1/4 x 6 in. Friends of Art Purchase Award M1965.56.

Pastil Chair, 1967–75, designed 1967. Eero Aarnio (Finnish, b. 1932). Fiberglass. 21 x 35 in. Gift of Friends of Art M2001.129.

Dining Table, 1982. Scott Burton (American, 1939–1989). Aluminum, lacquered wood. 28 1/2 x 79 1/2 x 51 1/4 in. Gift of Friends of Art M1983.288.